Making
America
Grate Again

A Collection of Political Cartoons

Charles Ray

North Potomac, MD

The words and art in this book represent the opinion of the author/artist, and if anyone is offended by his somewhat puckish sense of humor, sincere apologies are tendered. Political cartooning is by its very nature caricature of people, institutions and behavior, a shorthand to convey a message. So, if one of your favorite oxen is gored in these pages, don't take it personally.

No part of this book may be reproduced or transmitted by any means without the express written permission of the copyright holder. Brief, fair use portions may be used in connection with literary reviews or promotions

For more information about this author's work, or to request permission to use any of his works, please contact him at
charlesray.author@gmail.com

Cover art and design by the author

This book was manufactured in the United States of America

Copyright © 2017 Charles Ray

All rights reserved.

ISBN: 1548052906
ISBN-13: 978-1448052904

DEDICATION

To the men and women, military and civilian, who labor day and night, in some of the most inhospitable places on the planet—places like Washington, DC—unheralded, unappreciated, and often abused by the very people they serve, the employees of the United States Government, who drive the tanks, fly the planes, steer the ships, fill out the forms, man the gates, type the memos, and do all of the other grunt work that the politicians need so badly, miss when it's not done, and then trash during every election cycle..

INTRODUCTION

From 1976 to 1980, I moonlighted as editorial cartoonist for *The Spring Lake News*, a weekly paper published in Spring Lake, NC, a small town sandwiched between Pope Air Force Base and Fort Bragg where I was assigned. Even after being reassigned to Korea in 1979, I continued to draw my weekly cartoon until the distance from local events made it just too difficult, and I had to relinquish one of the most fun jobs I've ever done.

I continued to do cartoons, mostly gag panels for various magazines, until I retired from the army in 1982 and joined the Foreign Service. The buttoned-down bureaucrats at the State Department weren't quite as enlightened as my bosses in the army had been about off-duty activity, and the hassle of getting things cleared for publication caused me to confine my drawing for the next 30 years to birthday cards and congratulations to my co-workers and staff.

When I served in Zimbabwe as U.S. ambassador, I did the occasional editorial-like cartoon or blog in response to some of the government's misdeeds—even had one or two picked up by opposition newspapers. But, it wasn't until I left government service that the urge to use my pen to comment on political or social topics reasserted itself.

When I retired in 2012, I was already doing two blogs. They were devoted to mostly tame stuff, book reviews, the occasional commentary on social issues that didn't rise to the level of official interest, and travelogues—with the occasional cartoon to illustrate them. I even managed to find clippings of some of my old work, which I converted into digital files, which I occasionally published. When the 2016 political campaign got into full swing, though, I was juiced; especially when the unlikeliest of candidates seemed to be sweeping the field. I mean, a bombastic, misogynistic, egomaniac reality TV star with a checkered business record was wiping the floor with his more experienced political opponents, and he was doing it with some of the most outrageous behavior I've seen since the racially charged southern campaigns of the 1950s when some candidates said really hateful things in their pursuit of the southern white vote. Then, of course, there was the dustup brewing between

the Clinton and Sanders camps, with Sanders occasionally saying something that caught my attention.

I started doing little scribbles at first, just of the things that really caught my eye. But, as the campaigns heated up, and it looked like Trump would win the GOP nomination, and then (shudder) when, thanks to the byzantine methods of the electoral college, he actually won the election, my 'poison pen,' as a friend of mine calls my cartoons, would not be restrained. I find something almost every day to write or draw about—occasionally forcing myself to ignore things so that I can concentrate on writing, which is my bread and butter these days. Imagine my surprise, though, when I glanced one day at the pile of finished drawings and half-finished sketches on the floor in the corner of my home office (I've yet to get around to getting proper filing cabinets), and saw that they were so high they were in danger of toppling over.

Well, I decided, might as well pull them together into a collection. Maybe someday my grandchildren will find them interesting, provided the country hasn't imploded or collapsed under the weight of the crap being dumped on it these days.

I hope that you, dear reader, gawker, or whatever you prefer to be called, will also enjoy them. I apologize if I've happened to gore one or more of your favorite oxen in these pages. One would hope that if you're of that inclination, the cover would have already turned you away. Don't take it personally. We can all agree to disagree, and disagree without becoming disagreeable. As I've gotten older, my hand's not as steady as it once was, and I fear my drawing has suffered for that. But, if you like what you see—I hope you will—and, if you appreciate the humor, take the time to leave a short review on Amazon or Goodreads, or somewhere. And, remember, when we lose the ability to laugh at the insane things going on around us, we're in danger of going insane ourselves.

Now, enough of the chit chat. Start turning the pages and enjoying the pictures.

THE CARTOONS

I'll try to present these in some kind of chronological order, but don't hold me to it. My attention was initially drawn, not by Donald Trump, but by the Clinton-Sanders campaign and some of the outrageous things I was hearing from the long list of GOP candidates, so those will be first. Trump, though, began to do to me what he was doing to the nation, just when you thought you'd heard the most outrageous thing, he'd up the ante. The guy's like sand fleas. He gets into every crevice of your body, your nose, eyes, and ears, and man, does he itch.

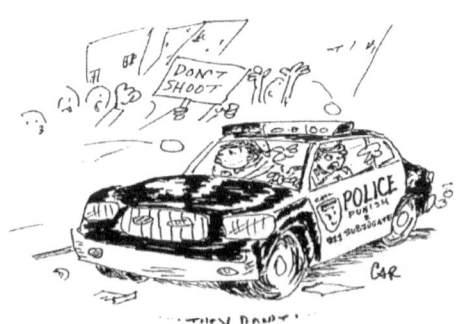

I did this to illustrate a blog post I did about police relations with minority communities, in the wake of several well-publicized shootings or killings of unarmed suspects.

Before the political got well underway, though, there were a number of tragic school shootings, and some of the subsequent pronouncements by politicians, gun advocates, and the National Rifle Association (NRA) really got my dander up. Whenever my dander gets up, I pick up my pen.

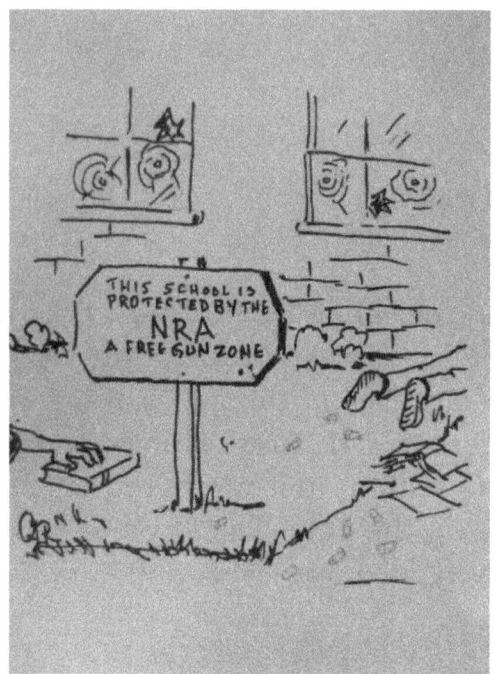
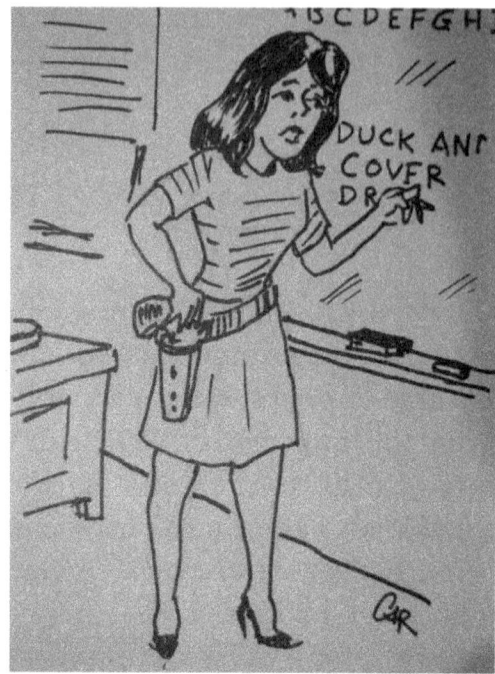

Someone, I won't say who, actually recommended *more* guns in schools as a safety measure, and that teachers should allow to carry in class.

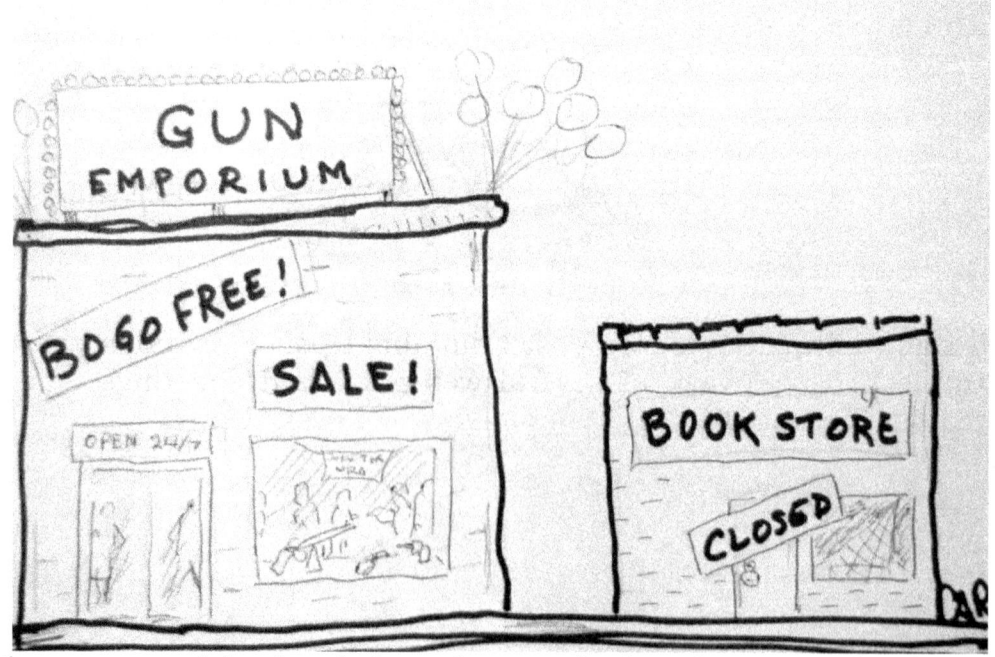

I read a news article that led to the conclusion that we valued access to guns over access to books. What a shame!

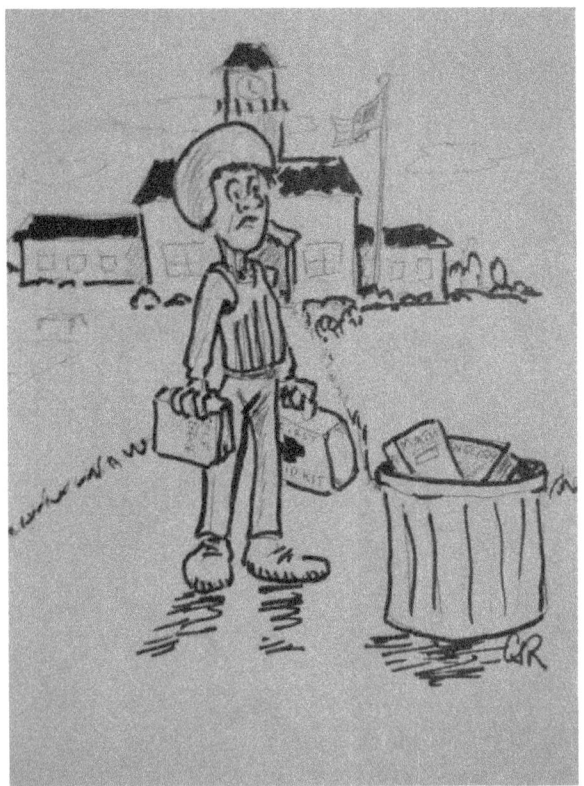

Is this what we want our schools to look like? Or this ⇨

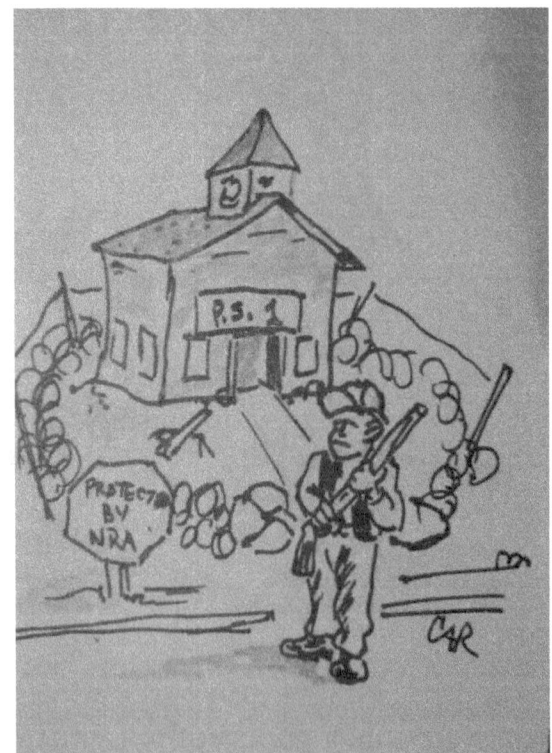

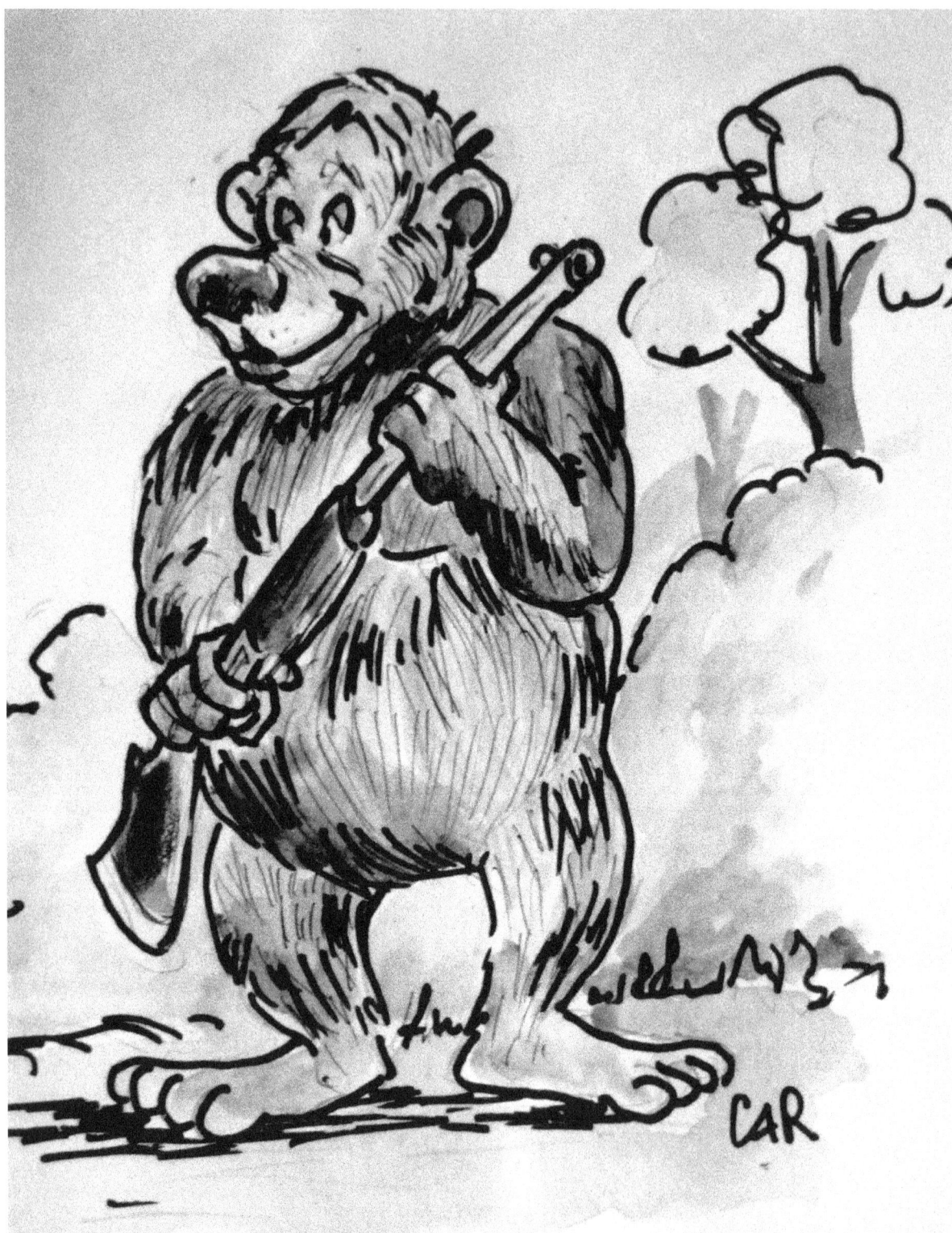

I did this 'I support the right to arm bears' as a play on what I've come to view as the bedtime prayer of Second Amendment devotees.

I grew up in Texas in the 40s and 50s, in a small rural town where everyone hunted, and everyone owned a gun. I was given my first gun, a single-shot .22 rifle, when I was seven. After graduating from high school, I joined the army, and spent the next 20 years around guns, including two tours in Vietnam during the war. I got a chance in the army, both abroad and here in the U.S., to see what guns could do to the human body, especially guns in the wrong hands. As a consequence, I am a strong supporter of sensible gun ownership laws, and things like background checks, eliminating the gun show loopholes, and keeping guns out of the hands of the mentally unstable, or people with a history of abusing others. That sounds a bit draconian, especially to Second Amendment devotees, but that's the way I feel, and the art on the foregoing pages expresses that in no uncertain terms. I'll never be invited to speak at an NRA convention, and because I write a mystery series with a main character who hates guns and, even though he's a PI, refuses to own or carry one, I've had some readers castigate me for it—at least, I hope they're still readers. My response; deal with it.

As the cover suggests, though, it is the Trump phenomenon that this book is about, and how that political revolution has shaped my art. It didn't start with him, per se, but with the three-ring circus that was the early days of the campaign, especially on the GOP side.

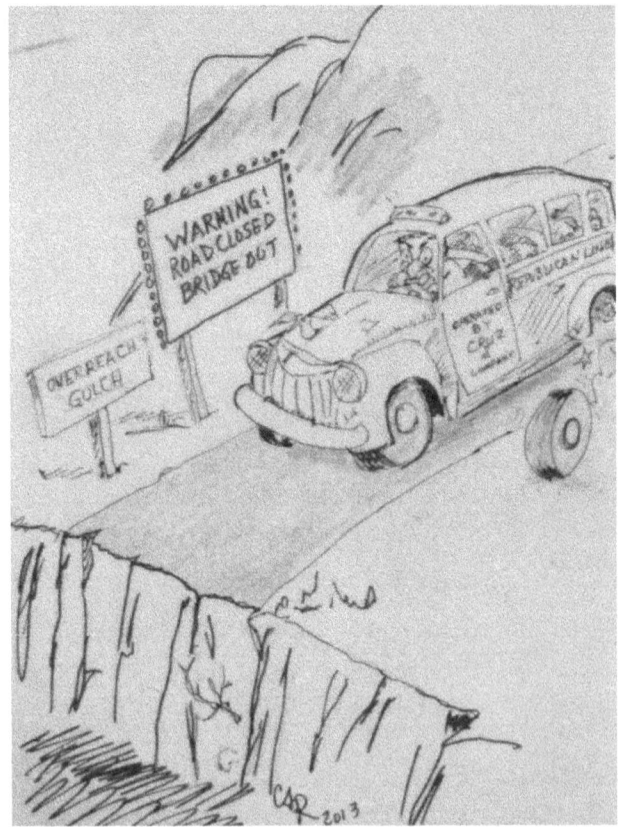

As far back as 2013, GOP candidates were saying things that shocked me to the core.

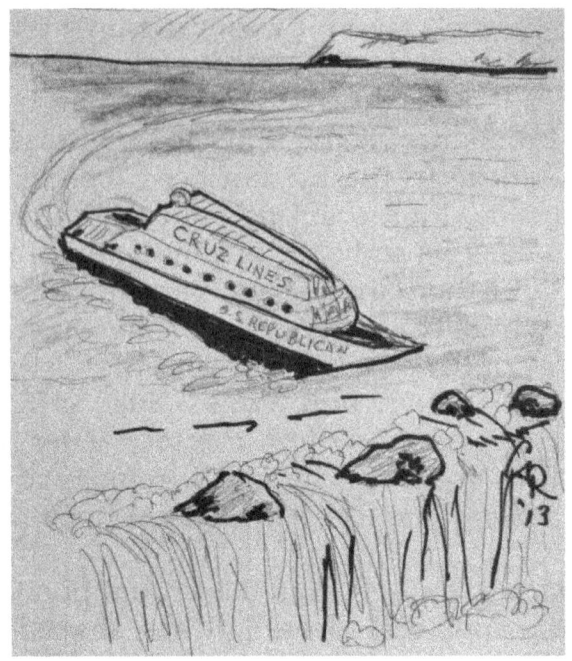

And, I was making what, I suppose, were some dire predictions.

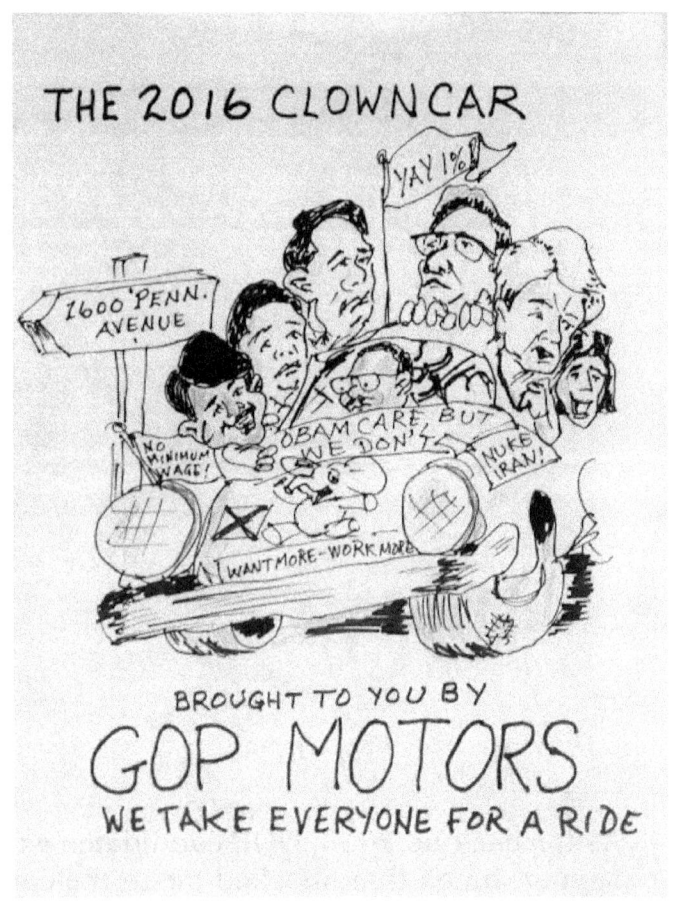

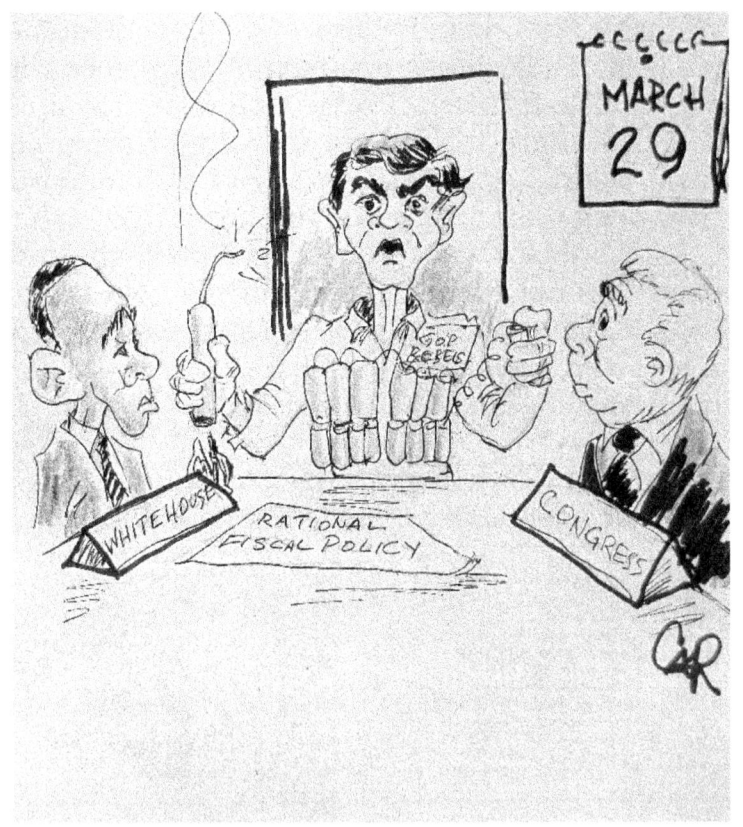

The anti-Obama hysteria was palpable. And then, along came Trump.

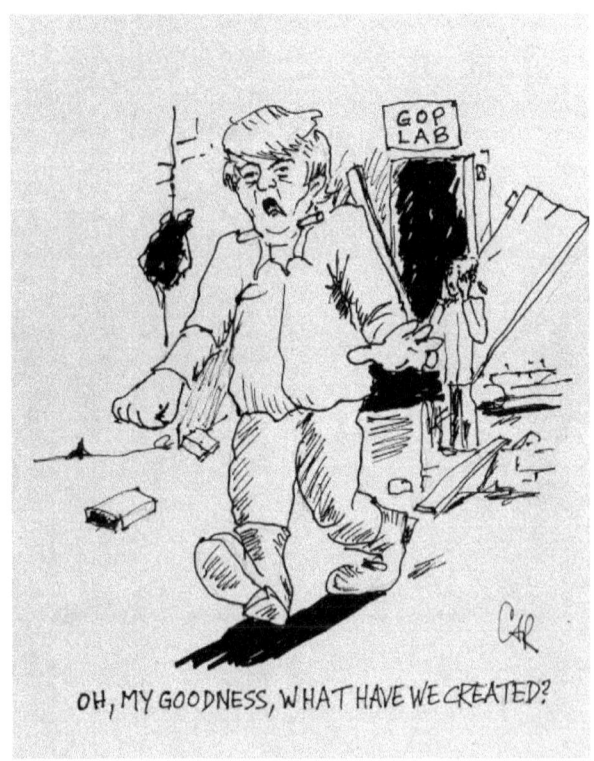

Of course, I'm giving the current crop of GOP politicians too much credit with that last cartoon. They didn't create him. The seeds for this particular weed were sown in 1964, when Barry Goldwater conducted his guerilla campaign to appeal to angry white men who could probably already see the demographic clock ticking against them. This was followed, of course, by Nixon's southern strategy, etc., etc., but the inevitable result, I believe, was a Donald Trump, a candidate who conducted a slash and burn, take-no-prisoners' campaign against even members of his own adopted party (just in case you've forgotten, he once supported Democrats). Recognizing that he wasn't about to go away, I decided to prepare to draw him regularly, which is what I do with recurring characters in my comics.

Below are the steps to creating a cartoon Donald, from the first pencil sketch to a final, shaded rendering of my main character.

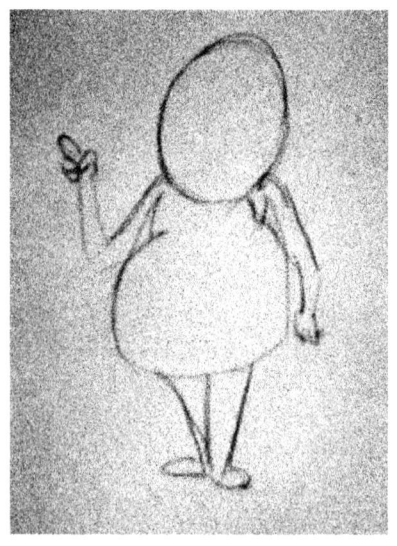
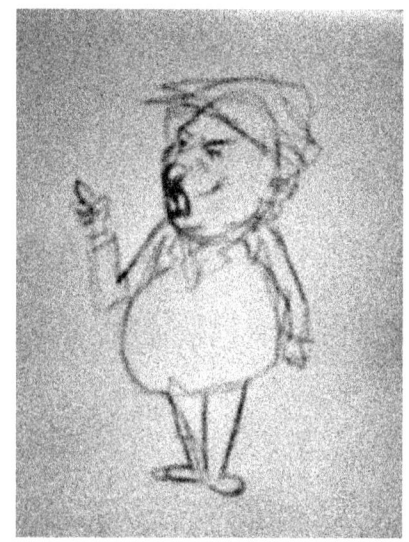
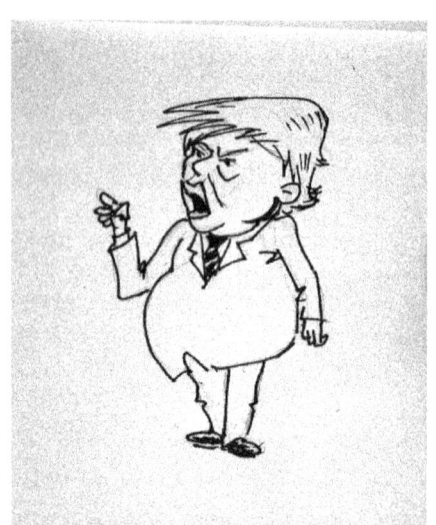
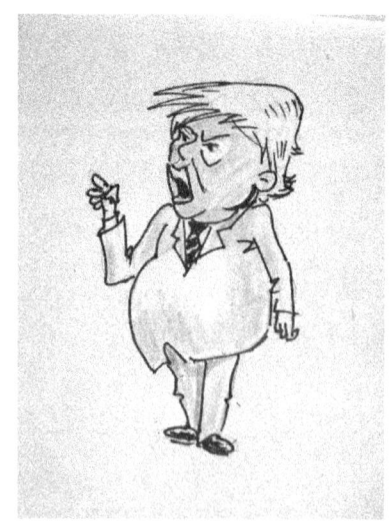

Of course, I couldn't forget his signature logo cap.

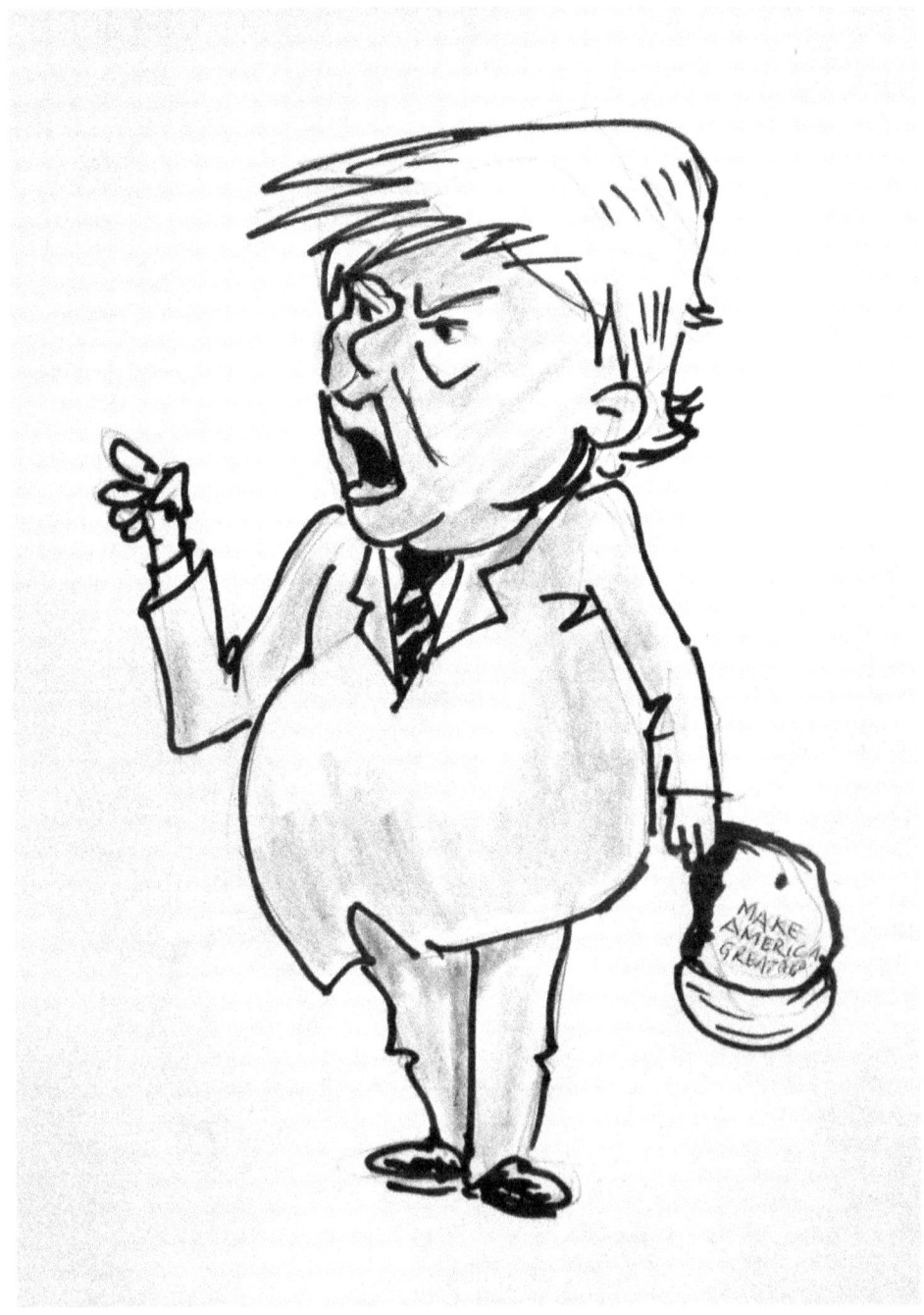

If this looks familiar, that's because a colorized version of it is on the cover of this book.

But, here's the first time I used it in a published cartoon on my blog, 'Free flow of ideas is the cornerstone of democracy http://charlesaray.blogspot.com/, Daily Kos (http://www.dailykos.com/user/Charles%20Ray/) among others.

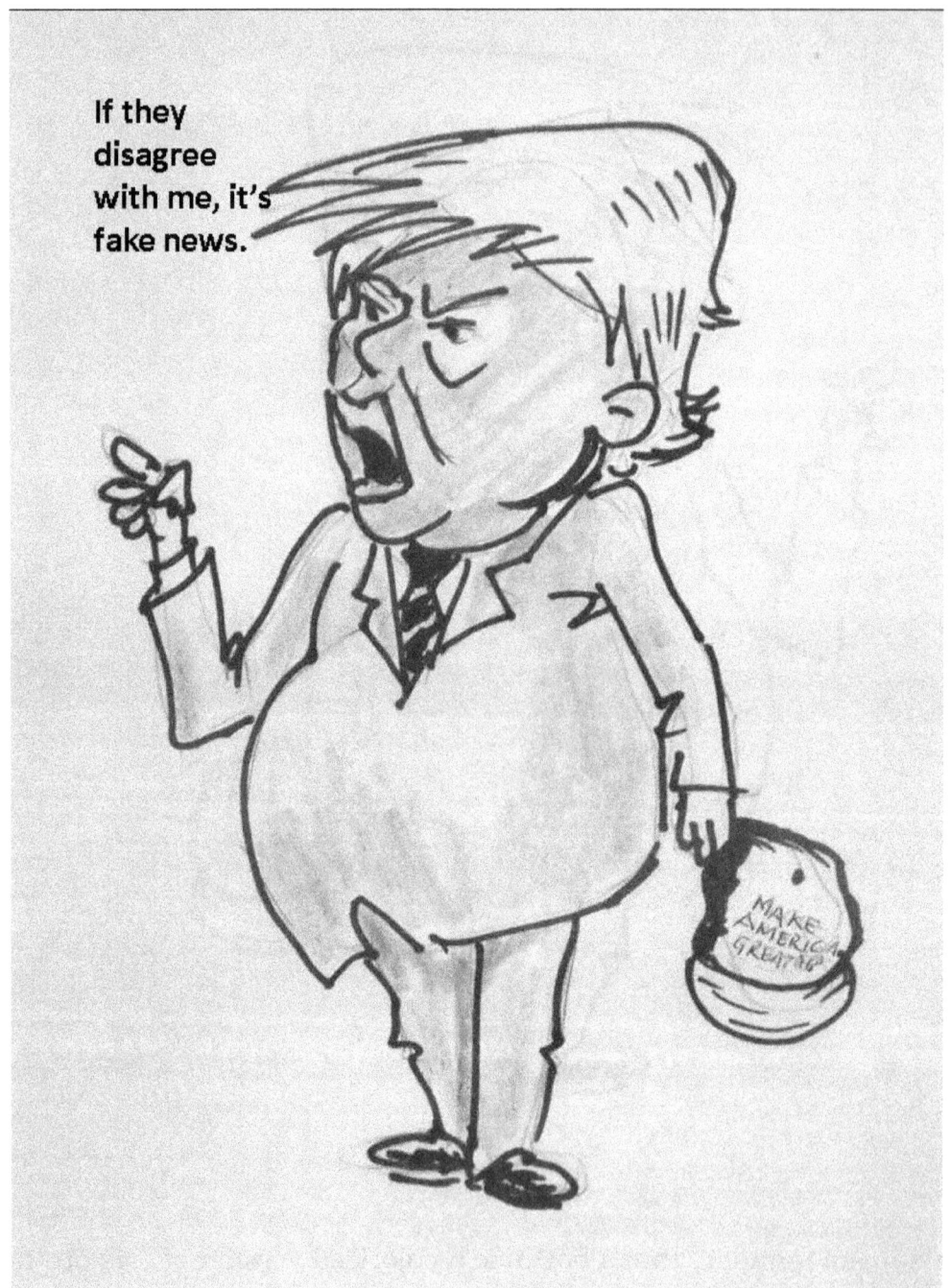

Pay attention to that term, 'fake news;' it'll appear again.

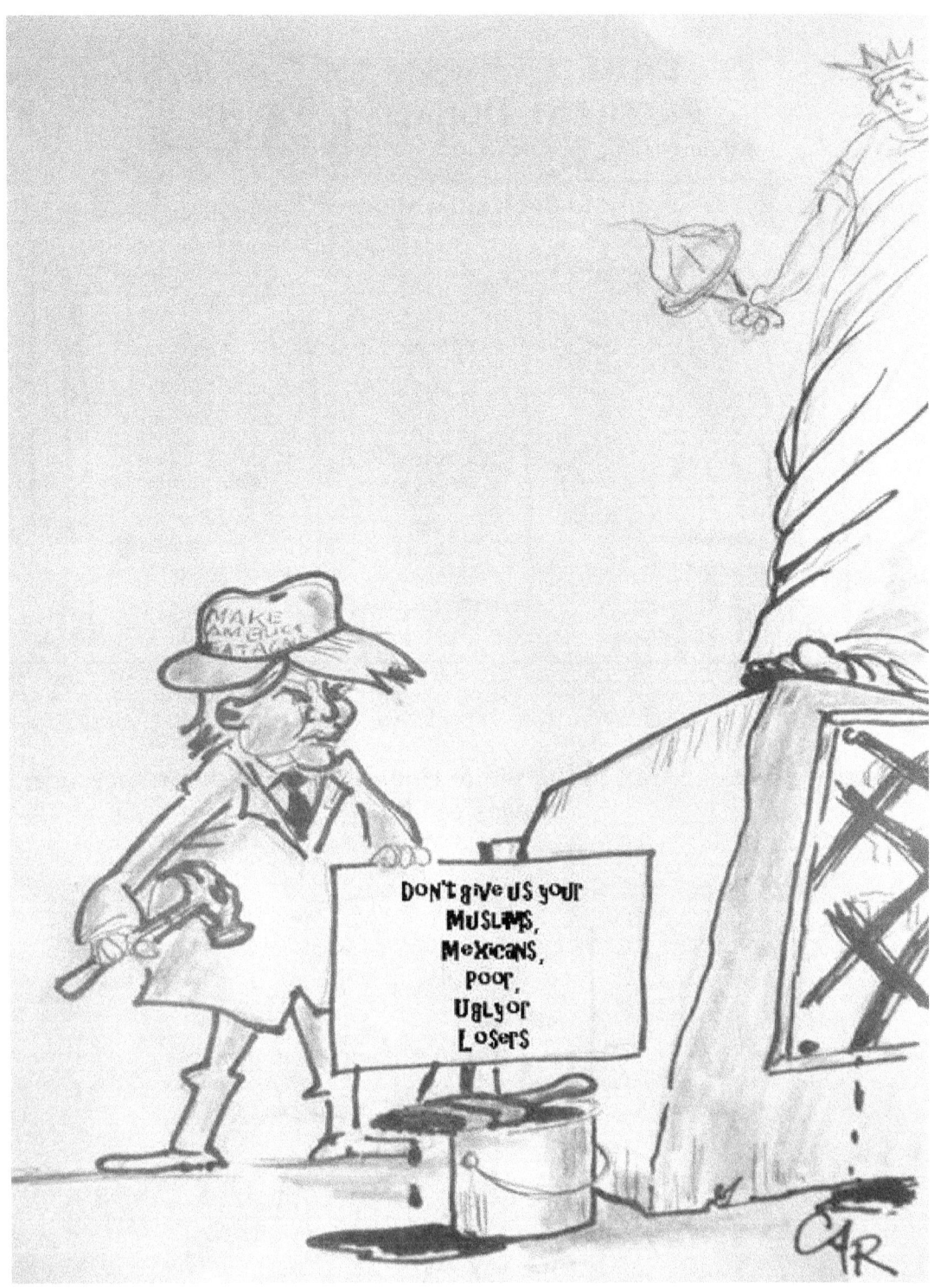

When the candidate started with his anti-immigrant message, this was my reaction.

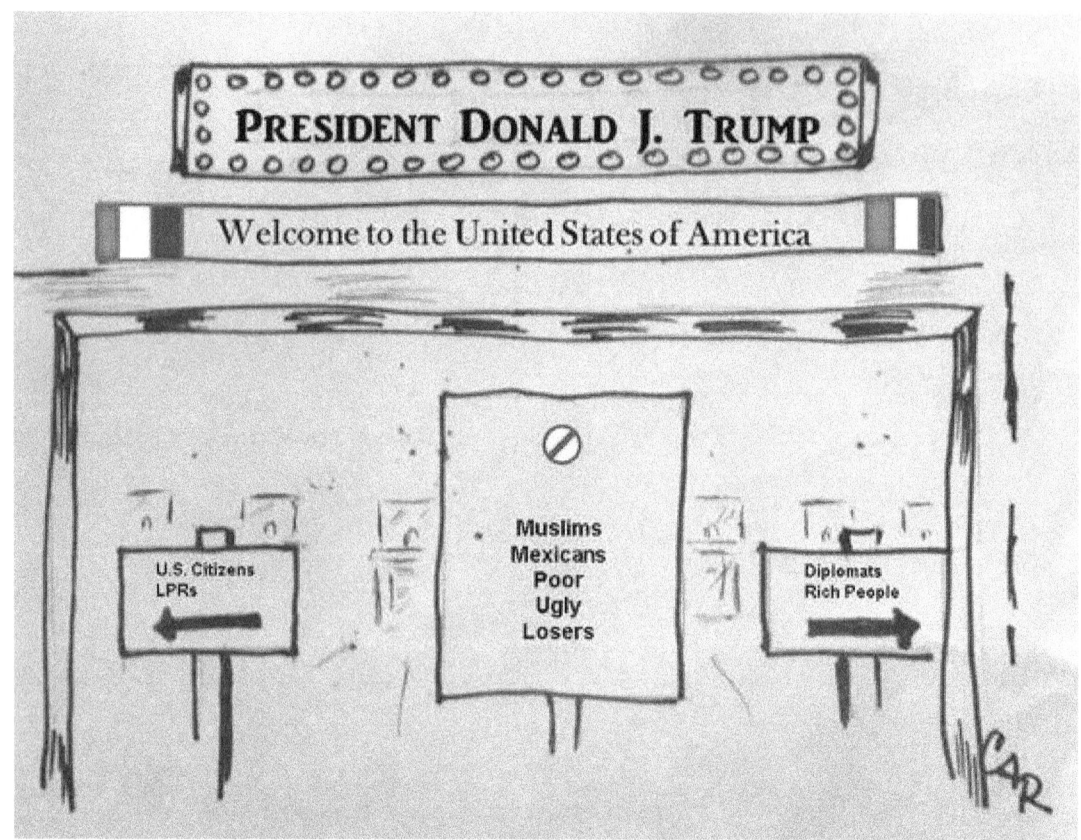

From the campaign trail to the White House, he was still on message, and it was scary.

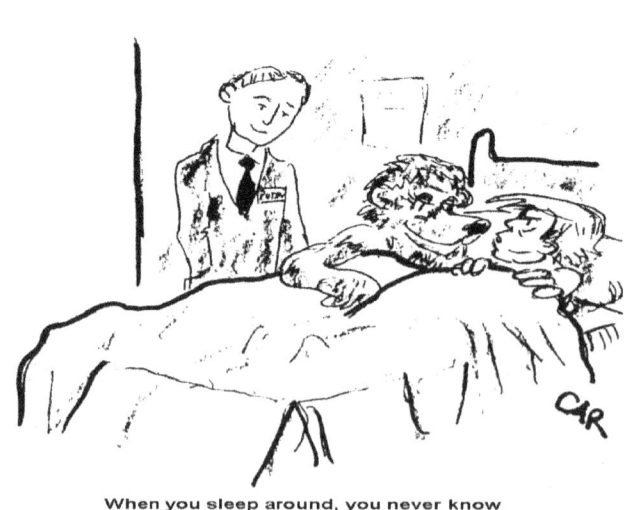

When you sleep around, you never know who or what you'll wake up with.

I was concerned about his Russian connection early.

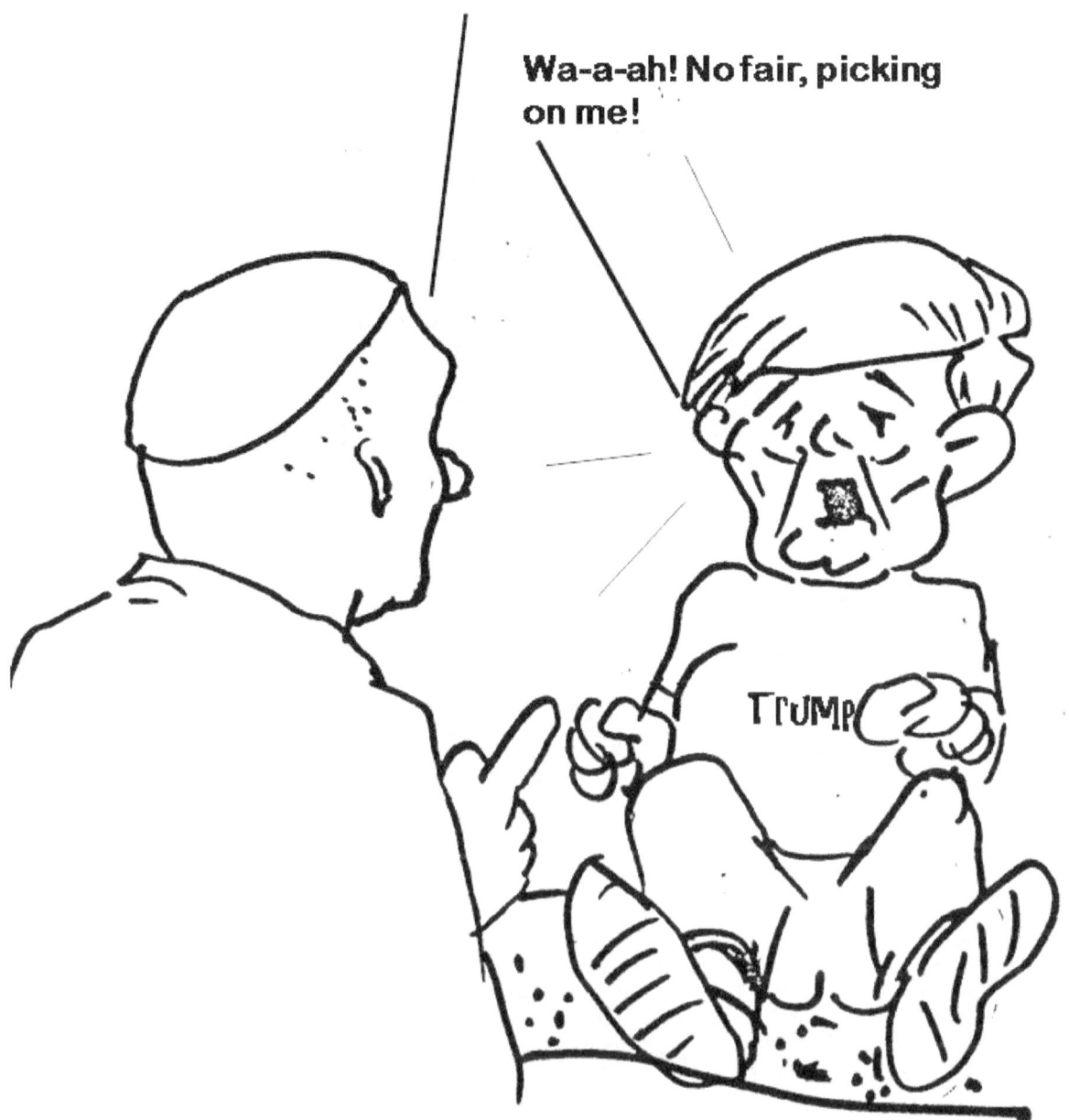

No one was exempt from Trump's ego, not even the Pope.

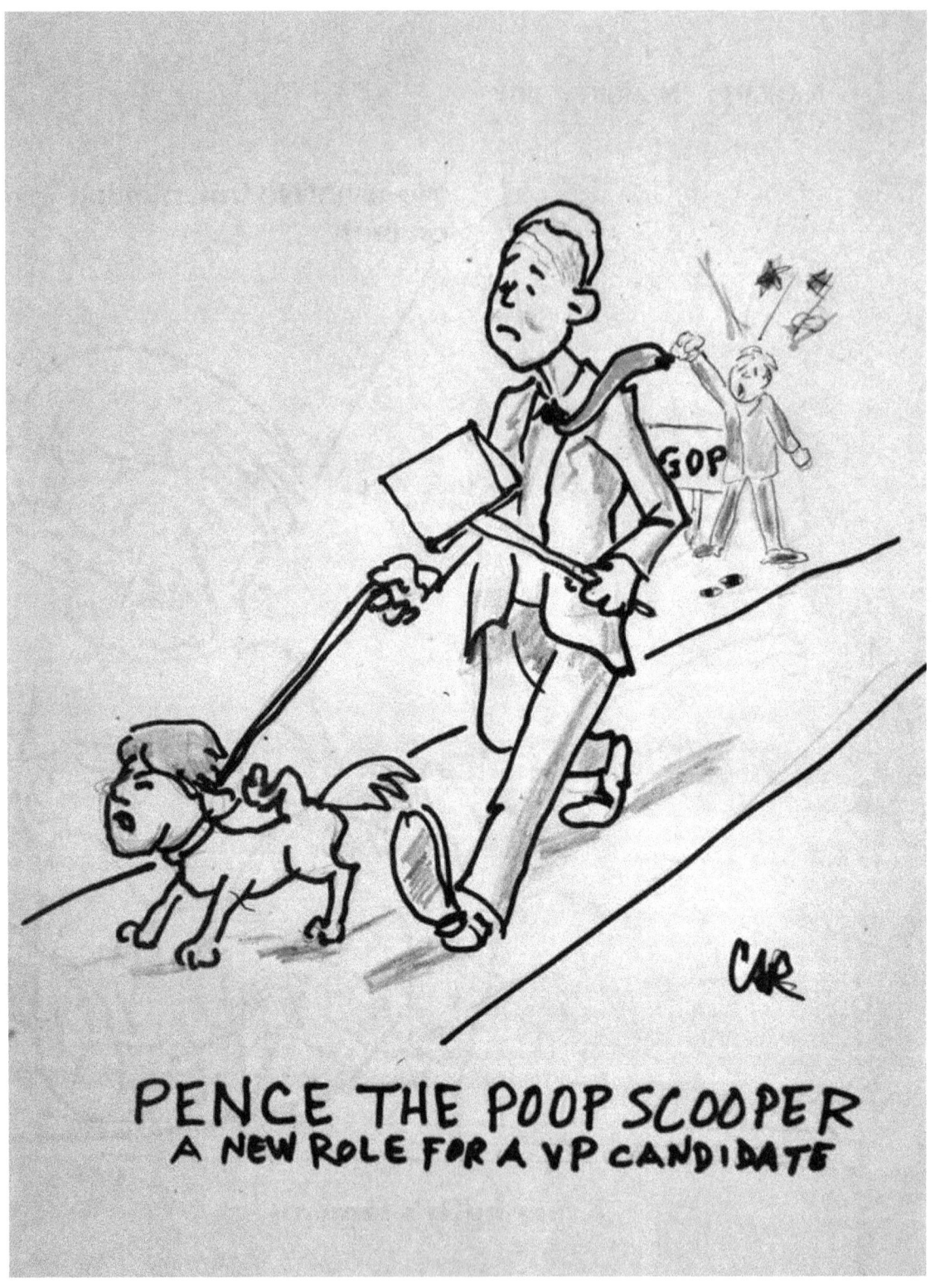

Even during the campaign, VP-candidate Pence had to clean up behind his new boss.

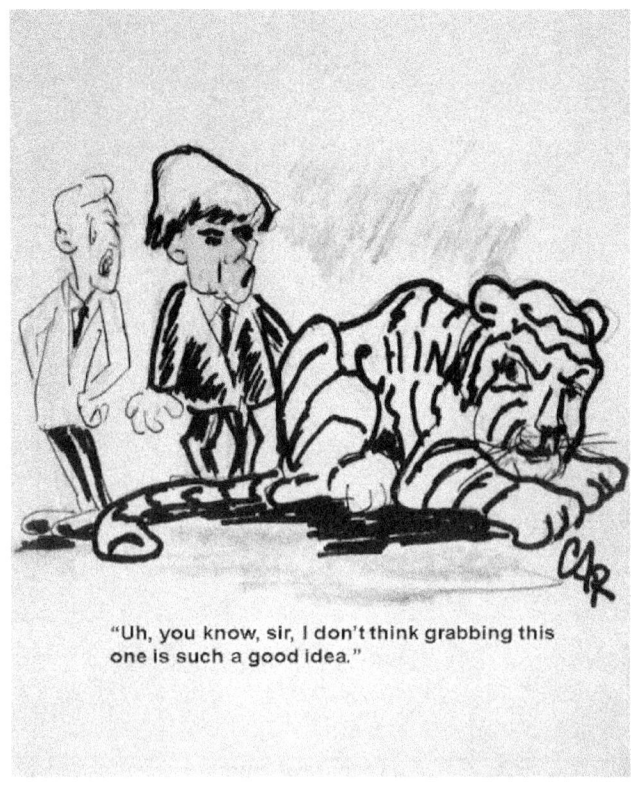

And, then there was that 'grabbing them' recording, at around the same time he was poking the Chinese in the eye.

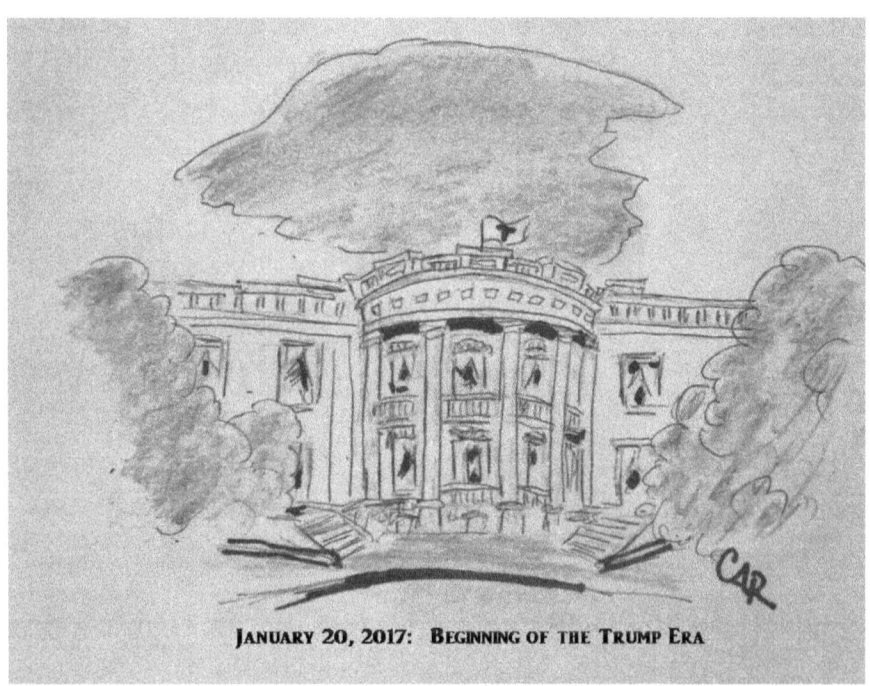

My Inauguration Day offering.

This was how I saw the GOP and media reaction to Trump's many faults.

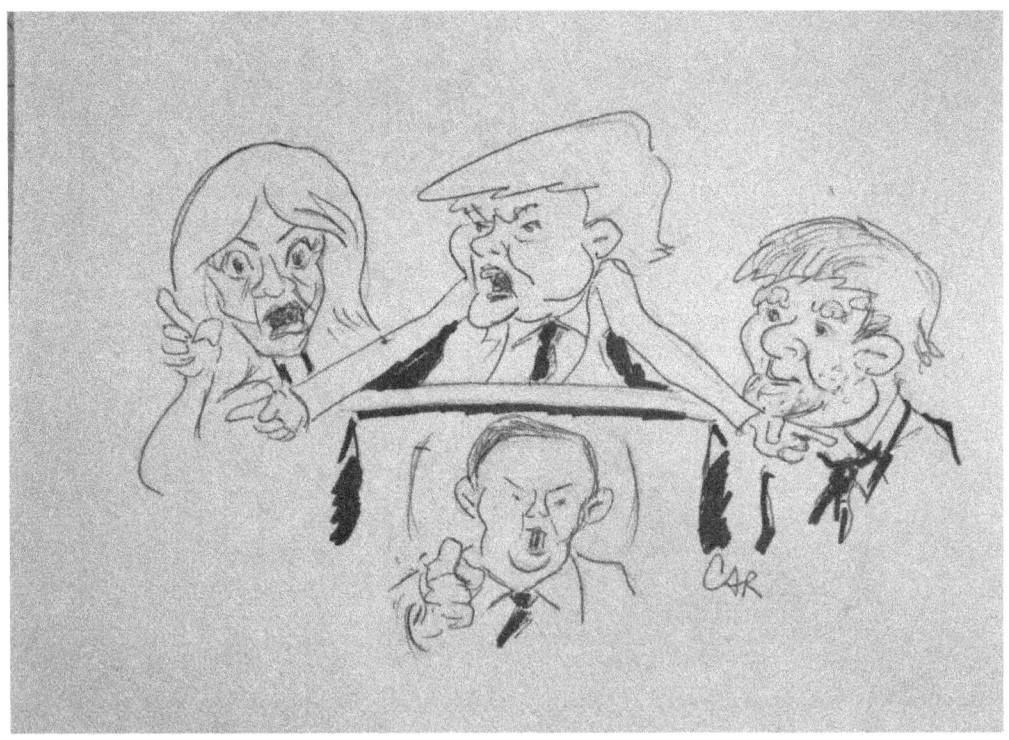

Shortly after he took office, we got a look at some of his close confidantes/advisors – what I called his Rogues Gallery.

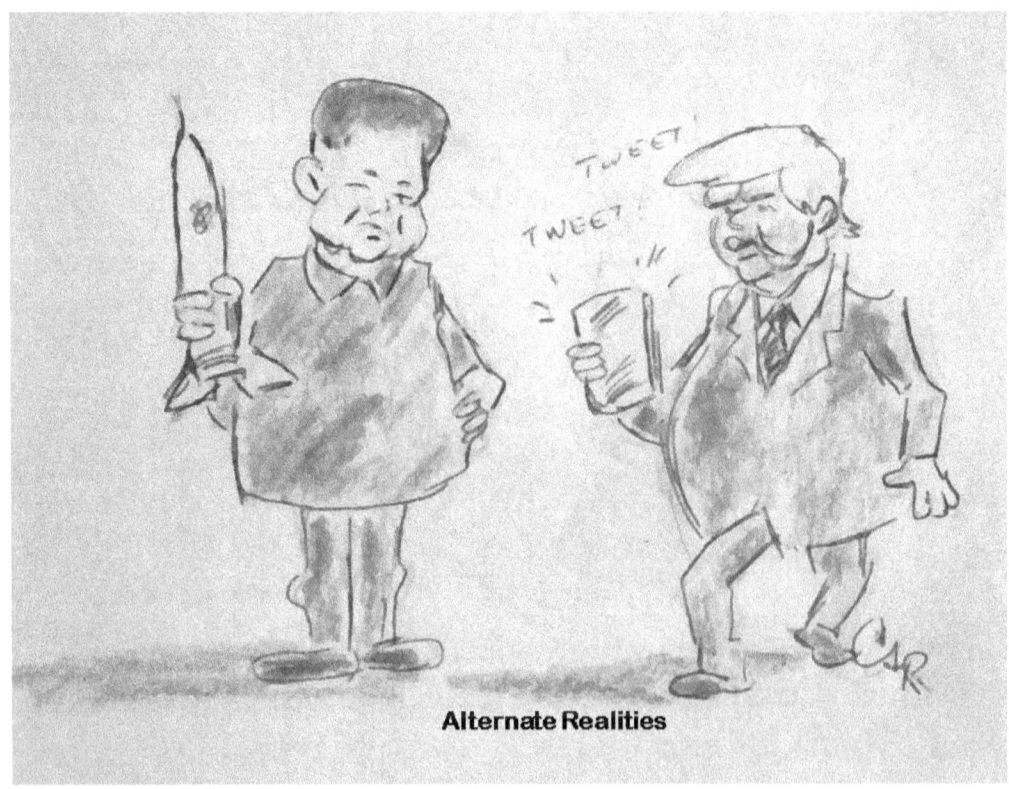

Alternate Realities

And then, he got into a pissing match with someone who is as impulsive as he is, North Korea's Kim Jong-un.

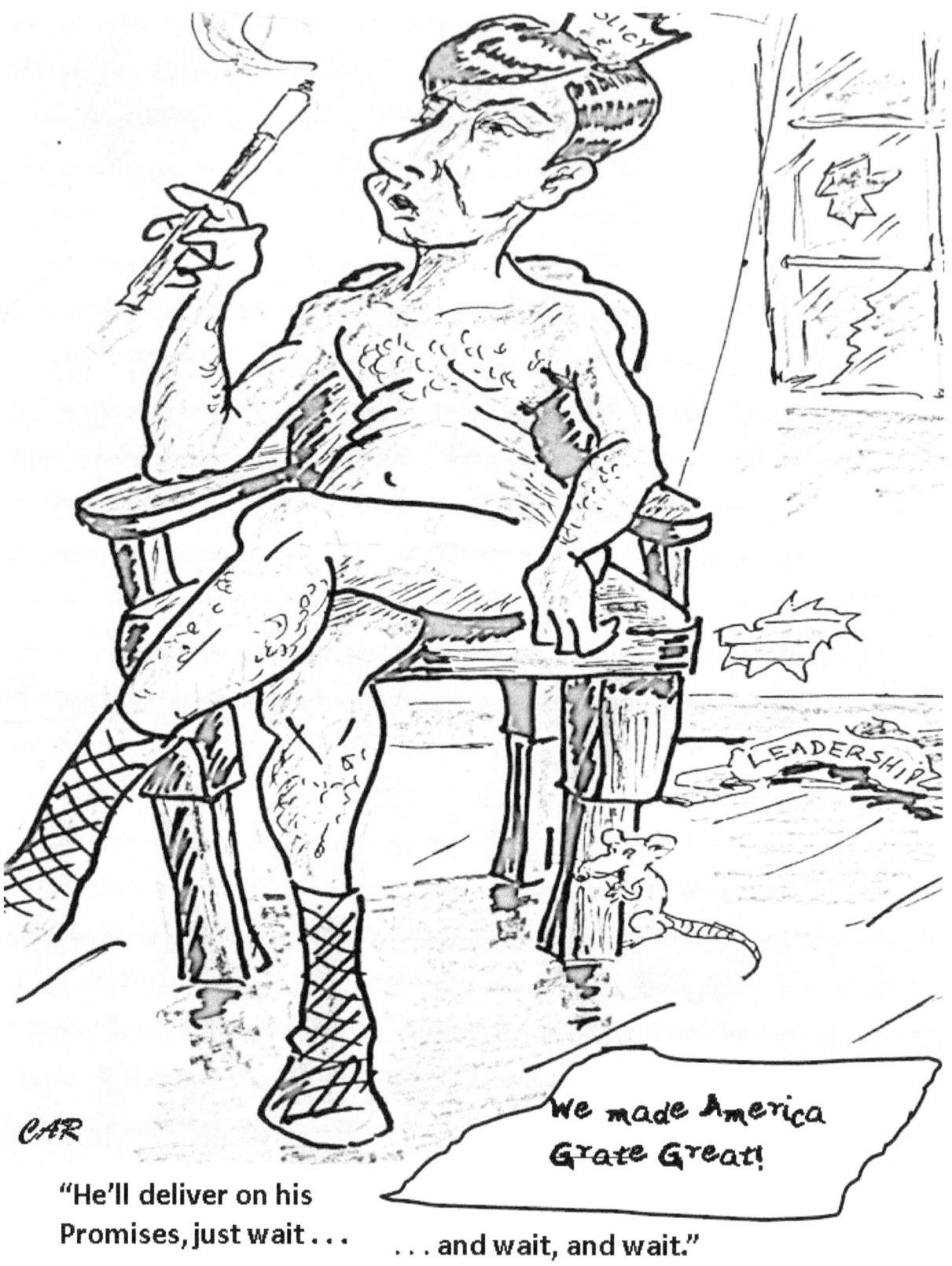

A few weeks after the election, I began to wonder if Trump voters were suffering buyers' remorse yet.

But, he just kept on chugging, his popularity dropping ever lower, and the GOP just kept making excuses for him..

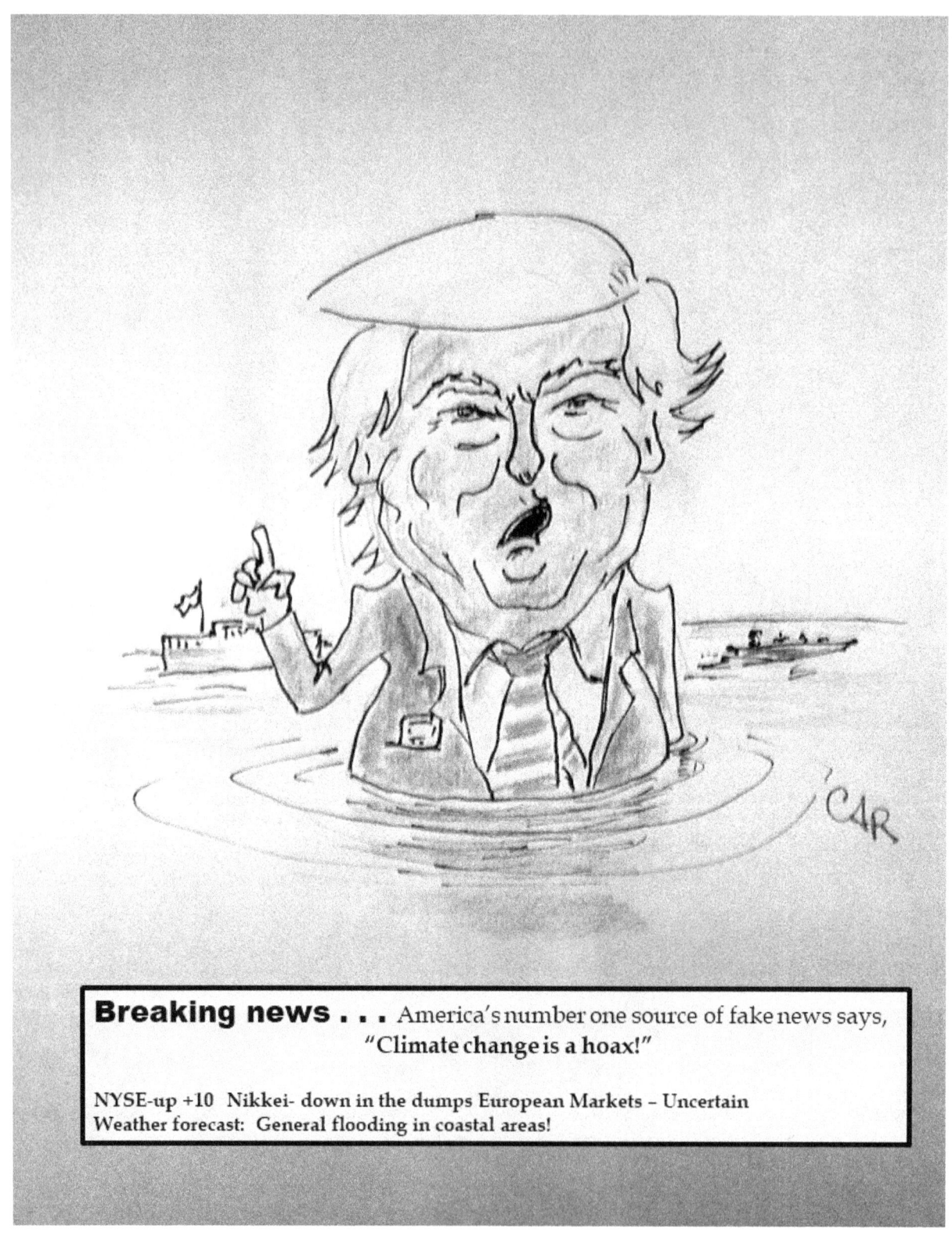

He pulled the US out of the Paris Climate Agreement, to the delight of the climate change deniers and the companies that gloat at the prospect of being able to pollute without restriction.

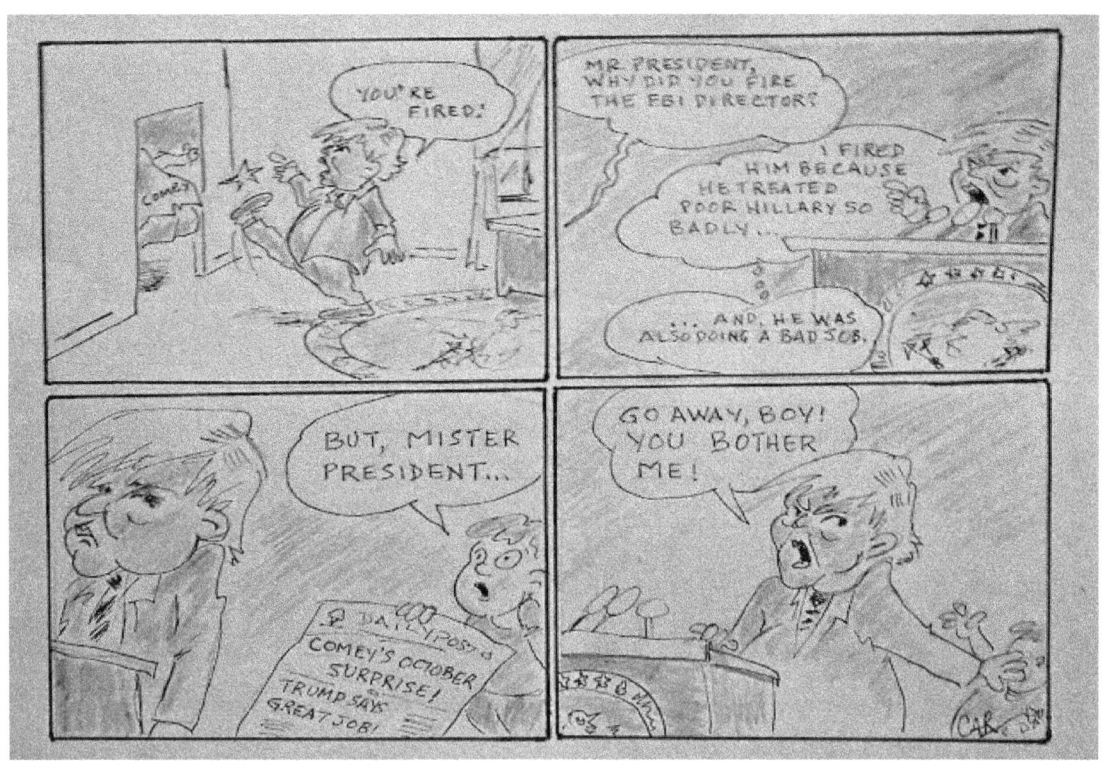

Then, his FBI Director remembered that he had an oath, not to Trump, but to the Constitution, and things started to come apart.

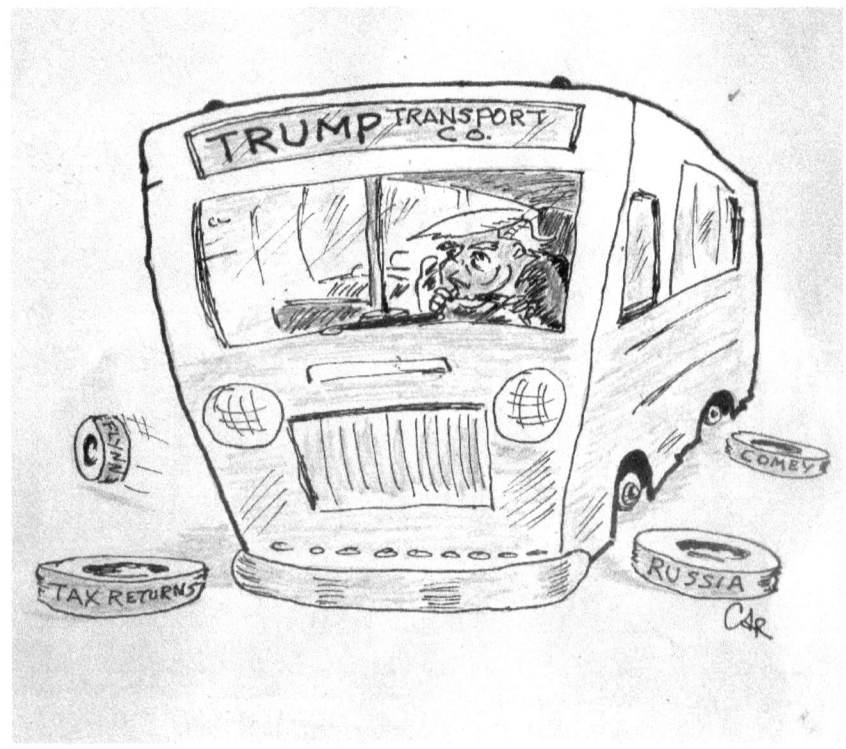

The caption for this was 'The wheels on the bus keep falling off, falling off, . . ."

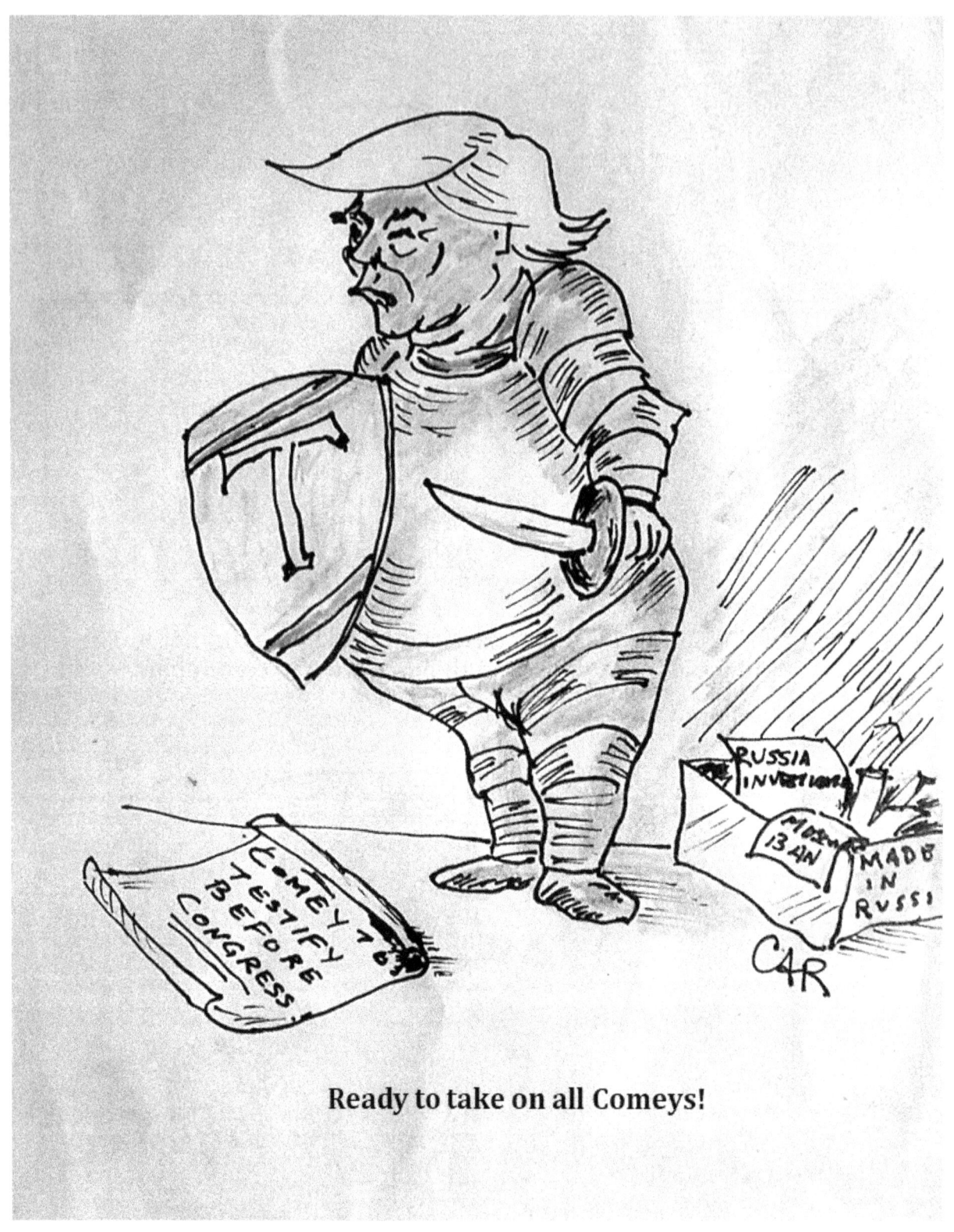

But The Donald doesn't go down without a fight.

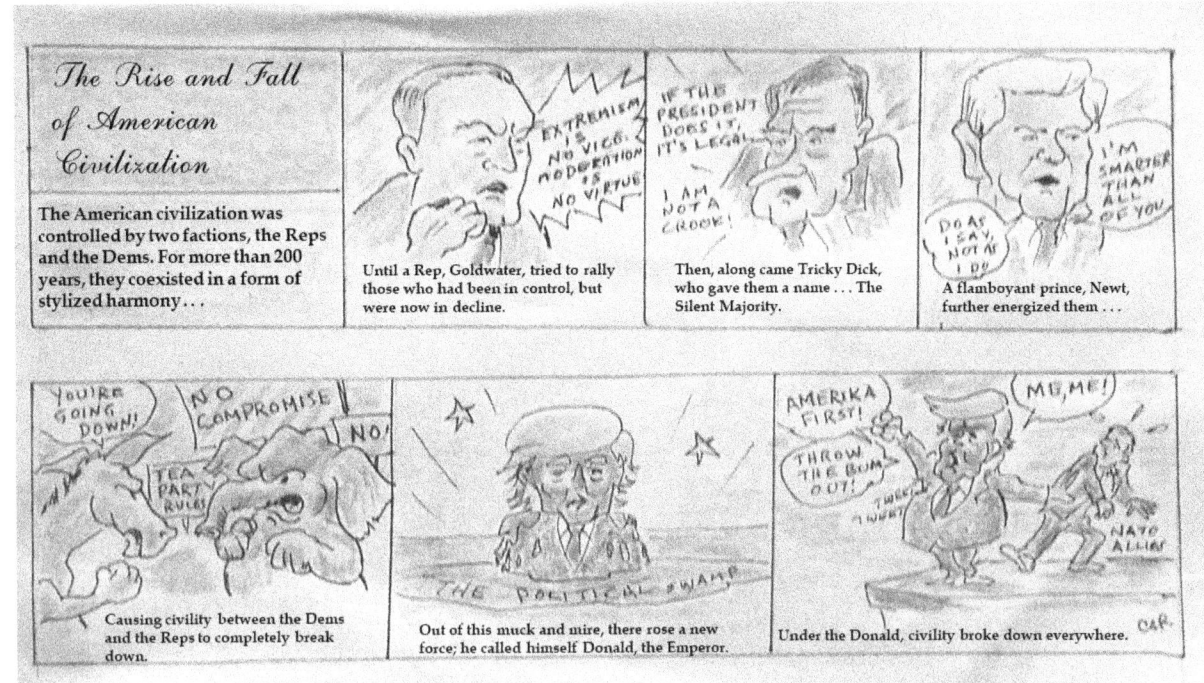

The lack of civility of his campaign moved with him to the White House, but, surprise, he didn't invent it. He was a product of a long-term trend that traces back 1964 and Barry Goldwater.

This probably explains why the GOP finds it so hard to disavow him. While they suffer as much as anyone from his public gaffes, late-night tweets, and his tendency to attack anyone who disagrees with him, is what he deems a 'loser,' or who is getting more media attention than he is. People like Kentucky Senator Mitch McConnell, who is determined to remake the Supreme Court, indeed, the entire federal court system, over in the image envisioned by Goldwater and others many decades ago, a tool to help advance a far, far right agenda, and stem the demographic tide that sees white voters becoming a minority and corporate fat cats restricted in their ability to deep freely into our pockets and the public purse at will.

His unpredictability, which is a long-term political liability, and his disdain for compromise, or admitting to being wrong or responsible for anything, as well as his tendency to strike out in anger when his ego is threatened, seems to be the price they're willing to pay to achieve their unachievable goals.

There you have it folks, my poison pen jottings up to five months into the Trump Administration. I'd like to be able to say that it won't get worse, but I've been around too long to be that naïve. I'll be doing more, probably enough more to do a second edition to coincide with the administration's first anniversary in January 2018. Stay tuned.

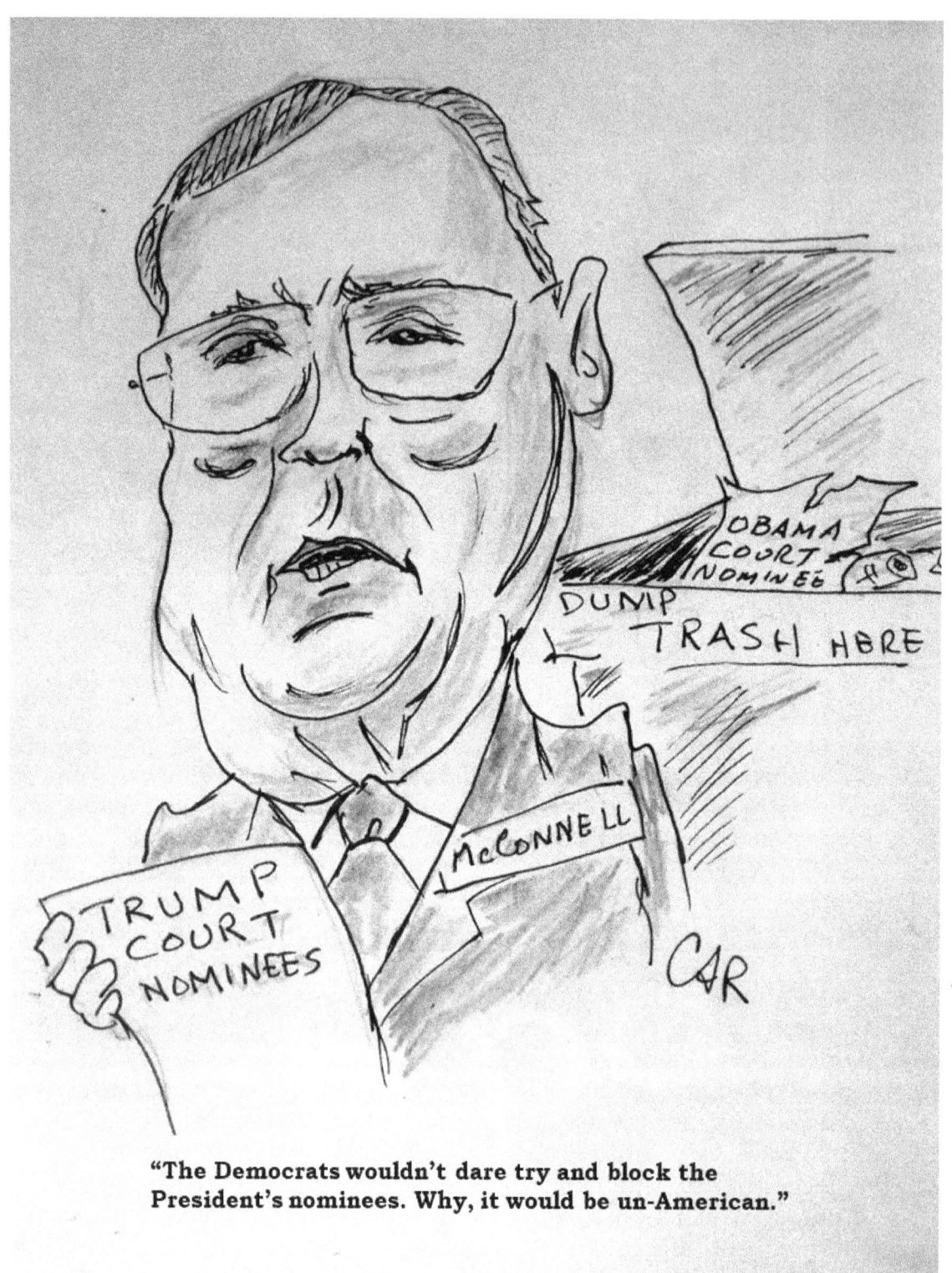

"The Democrats wouldn't dare try and block the President's nominees. Why, it would be un-American."

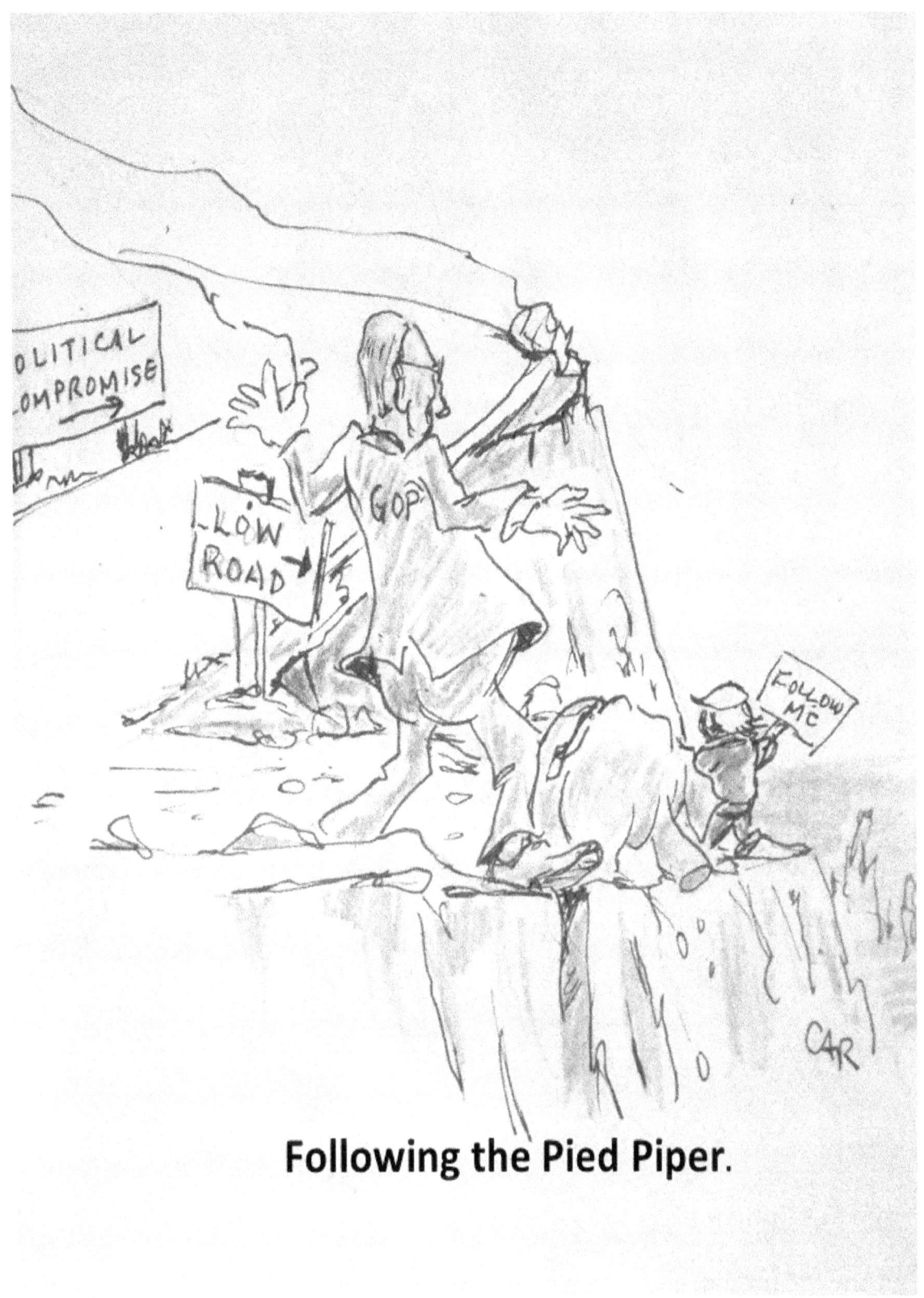

Following the Pied Piper.

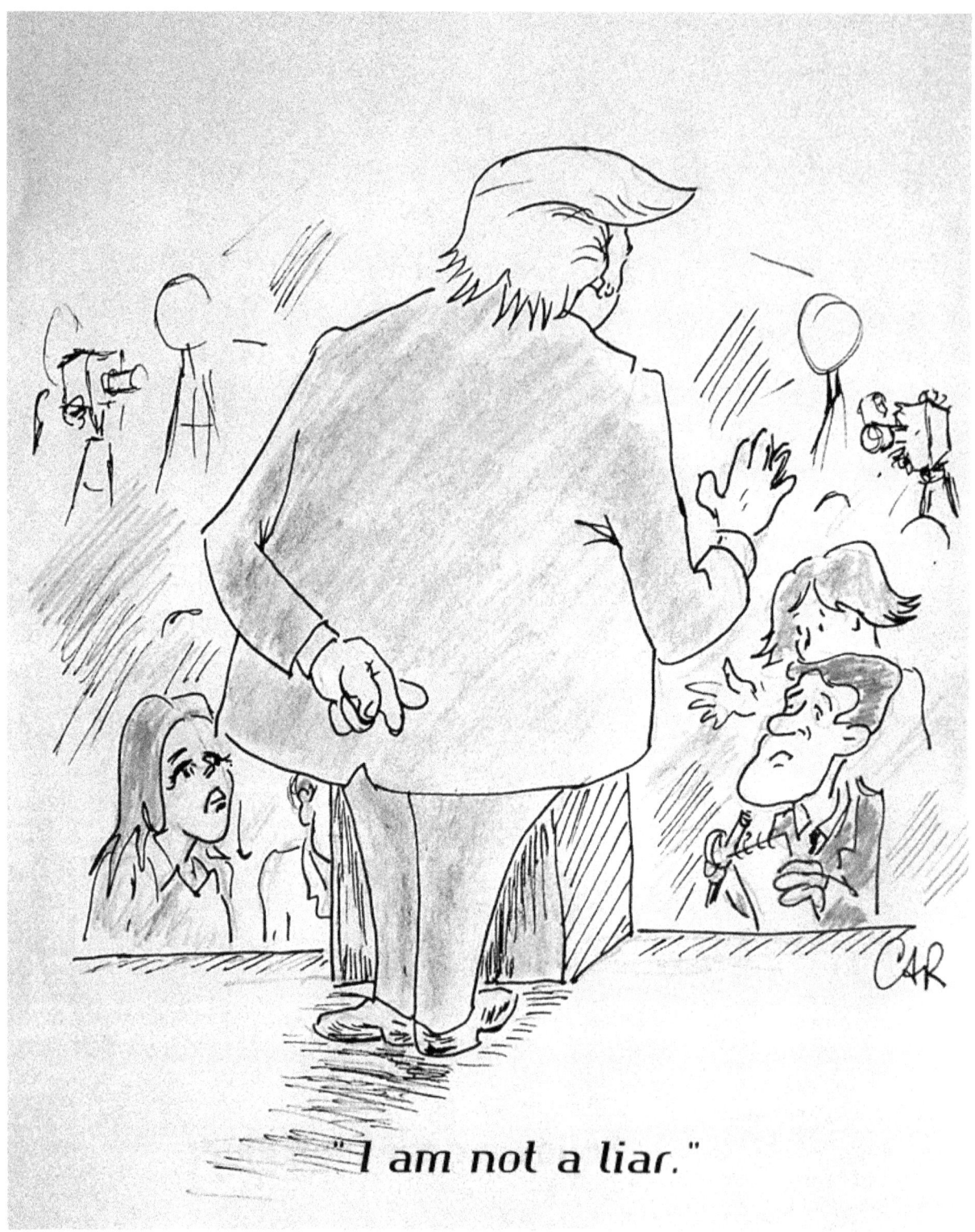

In the meantime, when he's caught in yet another tangle, he continues to do what he's famous for, deny and defame.

Author's Note

If you like what you've just read, please consider leaving a review, even just a few words, on Amazon, Goodreads, or the site from which you purchased the book.

For a look at all of my published books, check out my Amazon author page at: https://www.amazon.com/Charles-ray/e/B006WMLEZK/

CHARLES RAY

ABOUT THE AUTHOR

Charles Ray has been writing, drawing, painting, and taking pictures since his teens. His first professional writing credit was a byline on a short story that won first place in a national Sunday school magazine when he was twelve or thirteen. During high school, he made pocket money by drawing cartoons for his classmates, and taught himself to paint using panels torn off cardboard boxes as canvasses. His first photo was taken when he was about four years old, when his mother left her old Kodak Brownie unguarded on a table (circa 1949) and he did a selfie, which was lost in a fire at his mother's house, so he's unable to claim credit for invention of selfies.

After graduation from high school in 1962, he joined the army, and spent the next twenty years moving about the world, from Germany to Vietnam, writing poems for *Stars and Stripes*, moonlighting as a feature writer and photographer for newspapers and magazines, and while serving at Fort Bragg, NC in the 1970s, serving as the editorial cartoonist for *The Spring Lake News*, a weekly paper in the small community sandwiched between Ft. Bragg and Pope Air Force Base. He's done gag cartoons for a number of publications, many of which are no longer in publication, through no fault of his.

Ray is the author of more than 60 works of fiction and nonfiction, including two mystery series, a western series featuring the famed Buffalo Soldiers of the Ninth Cavalry, and a fictionalized account of the life of Bass Reeves, one of the first African-American deputy U.S. marshals west of the Mississippi, who was hired to track and arrest fugitives in Oklahoma's Indian Territory in the decades after the Civil War.

He grew up in a small town in East Texas (and, by small, the population was 715), which he left before his seventeenth birthday. Since then, he's lived all over the world, and has visited every continent except Antarctica. He now calls Maryland home, living in a Montgomery County suburb just outside Washington, DC.

When he's not writing, drawing, or taking pictures, he plays with his grandchildren, who live nearby, engaged in public speaking or lecturing, and working with a number of non-governmental organizations concerned with history and foreign affairs.

www.ingramcontent.com/pod-product-compliance
Lightning Source LLC
Chambersburg PA
CBHW081102160126
38357CB00033B/423

Making
America
Grate Again

A Collection of Political Cartoons

Charles Ray

North Potomac, MD

The words and art in this book represent the opinion of the author/artist, and if anyone is offended by his somewhat puckish sense of humor, sincere apologies are tendered. Political cartooning is by its very nature caricature of people, institutions and behavior, a shorthand to convey a message. So, if one of your favorite oxen is gored in these pages, don't take it personally.

No part of this book may be reproduced or transmitted by any means without the express written permission of the copyright holder. Brief, fair use portions may be used in connection with literary reviews or promotions

For more information about this author's work, or to request permission to use any of his works, please contact him at charlesray.author@gmail.com

Cover art and design by the author

This book was manufactured in the United States of America

Copyright © 2017 Charles Ray

All rights reserved.

ISBN: 1548052906
ISBN-13: 978-1448052904

DEDICATION

To the men and women, military and civilian, who labor day and night, in some of the most inhospitable places on the planet—places like Washington, DC—unheralded, unappreciated, and often abused by the very people they serve, the employees of the United States Government, who drive the tanks, fly the planes, steer the ships, fill out the forms, man the gates, type the memos, and do all of the other grunt work that the politicians need so badly, miss when it's not done, and then trash during every election cycle..

INTRODUCTION

From 1976 to 1980, I moonlighted as editorial cartoonist for *The Spring Lake News*, a weekly paper published in Spring Lake, NC, a small town sandwiched between Pope Air Force Base and Fort Bragg where I was assigned. Even after being reassigned to Korea in 1979, I continued to draw my weekly cartoon until the distance from local events made it just too difficult, and I had to relinquish one of the most fun jobs I've ever done.

I continued to do cartoons, mostly gag panels for various magazines, until I retired from the army in 1982 and joined the Foreign Service. The buttoned-down bureaucrats at the State Department weren't quite as enlightened as my bosses in the army had been about off-duty activity, and the hassle of getting things cleared for publication caused me to confine my drawing for the next 30 years to birthday cards and congratulations to my co-workers and staff.

When I served in Zimbabwe as U.S. ambassador, I did the occasional editorial-like cartoon or blog in response to some of the government's misdeeds—even had one or two picked up by opposition newspapers. But, it wasn't until I left government service that the urge to use my pen to comment on political or social topics reasserted itself.

When I retired in 2012, I was already doing two blogs. They were devoted to mostly tame stuff, book reviews, the occasional commentary on social issues that didn't rise to the level of official interest, and travelogues—with the occasional cartoon to illustrate them. I even managed to find clippings of some of my old work, which I converted into digital files, which I occasionally published. When the 2016 political campaign got into full swing, though, I was juiced; especially when the unlikeliest of candidates seemed to be sweeping the field. I mean, a bombastic, misogynistic, egomaniac reality TV star with a checkered business record was wiping the floor with his more experienced political opponents, and he was doing it with some of the most outrageous behavior I've seen since the racially charged southern campaigns of the 1950s when some candidates said really hateful things in their pursuit of the southern white vote. Then, of course, there was the dustup brewing between

the Clinton and Sanders camps, with Sanders occasionally saying something that caught my attention.

I started doing little scribbles at first, just of the things that really caught my eye. But, as the campaigns heated up, and it looked like Trump would win the GOP nomination, and then (shudder) when, thanks to the byzantine methods of the electoral college, he actually won the election, my 'poison pen,' as a friend of mine calls my cartoons, would not be restrained. I find something almost every day to write or draw about—occasionally forcing myself to ignore things so that I can concentrate on writing, which is my bread and butter these days. Imagine my surprise, though, when I glanced one day at the pile of finished drawings and half-finished sketches on the floor in the corner of my home office (I've yet to get around to getting proper filing cabinets), and saw that they were so high they were in danger of toppling over.

Well, I decided, might as well pull them together into a collection. Maybe someday my grandchildren will find them interesting, provided the country hasn't imploded or collapsed under the weight of the crap being dumped on it these days.

I hope that you, dear reader, gawker, or whatever you prefer to be called, will also enjoy them. I apologize if I've happened to gore one or more of your favorite oxen in these pages. One would hope that if you're of that inclination, the cover would have already turned you away. Don't take it personally. We can all agree to disagree, and disagree without becoming disagreeable. As I've gotten older, my hand's not as steady as it once was, and I fear my drawing has suffered for that. But, if you like what you see—I hope you will—and, if you appreciate the humor, take the time to leave a short review on Amazon or Goodreads, or somewhere. And, remember, when we lose the ability to laugh at the insane things going on around us, we're in danger of going insane ourselves.

Now, enough of the chit chat. Start turning the pages and enjoying the pictures.

THE CARTOONS

I'll try to present these in some kind of chronological order, but don't hold me to it. My attention was initially drawn, not by Donald Trump, but by the Clinton-Sanders campaign and some of the outrageous things I was hearing from the long list of GOP candidates, so those will be first. Trump, though, began to do to me what he was doing to the nation, just when you thought you'd heard the most outrageous thing, he'd up the ante. The guy's like sand fleas. He gets into every crevice of your body, your nose, eyes, and ears, and man, does he itch.

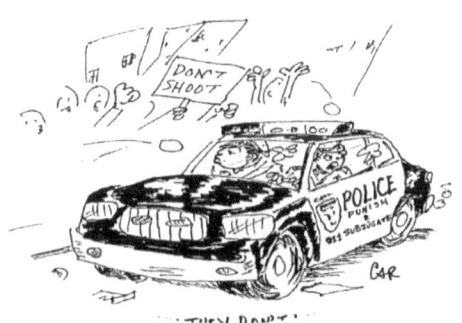

I did this to illustrate a blog post I did about police relations with minority communities, in the wake of several well-publicized shootings or killings of unarmed suspects.

Before the political got well underway, though, there were a number of tragic school shootings, and some of the subsequent pronouncements by politicians, gun advocates, and the National Rifle Association (NRA) really got my dander up. Whenever my dander gets up, I pick up my pen.

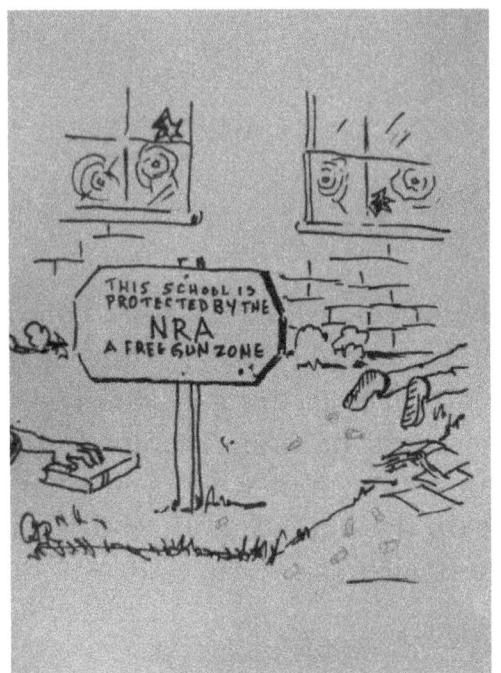 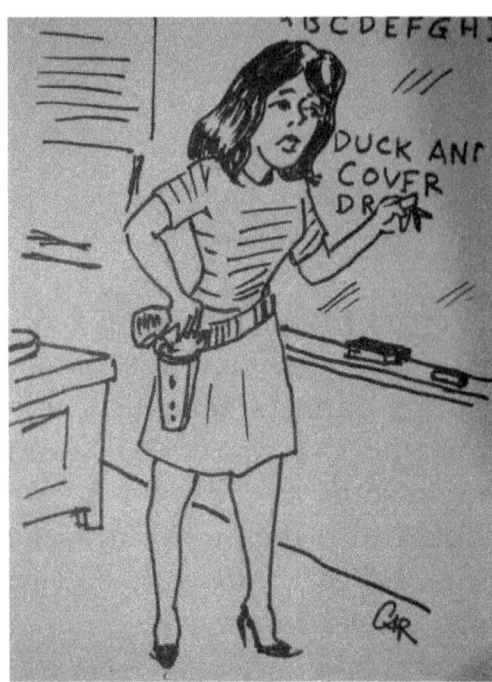

Someone, I won't say who, actually recommended *more* guns in schools as a safety measure, and that teachers should allow to carry in class.

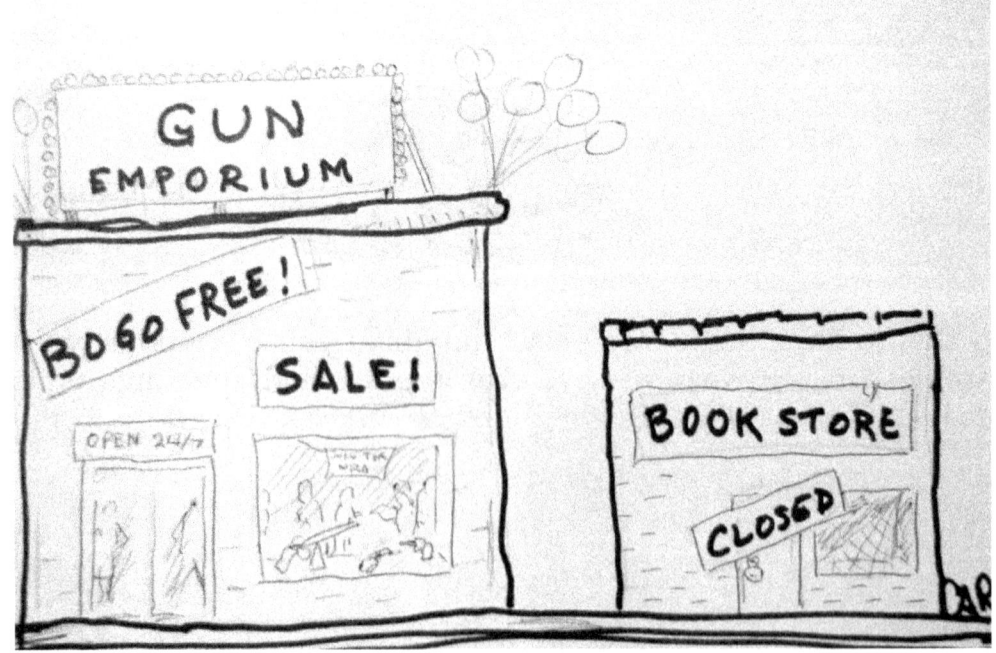

I read a news article that led to the conclusion that we valued access to guns over access to books. What a shame!

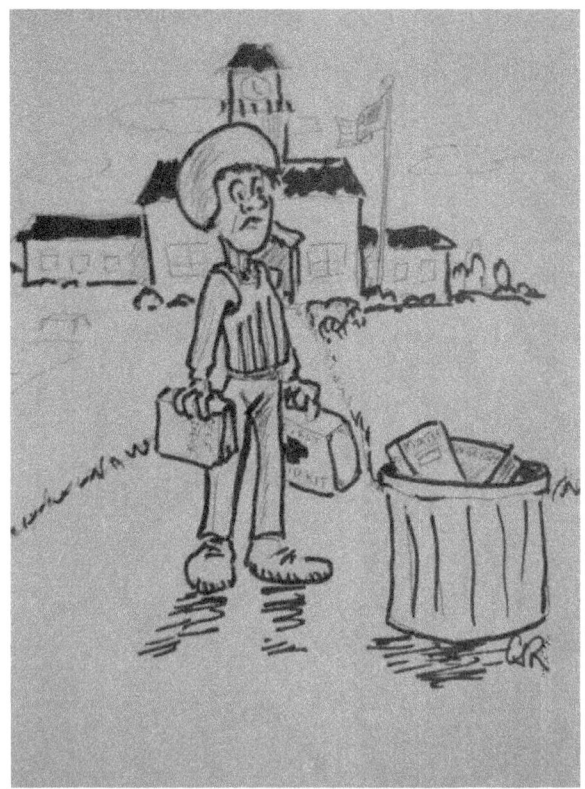

Is this what we want our schools to look like? Or this ⇒

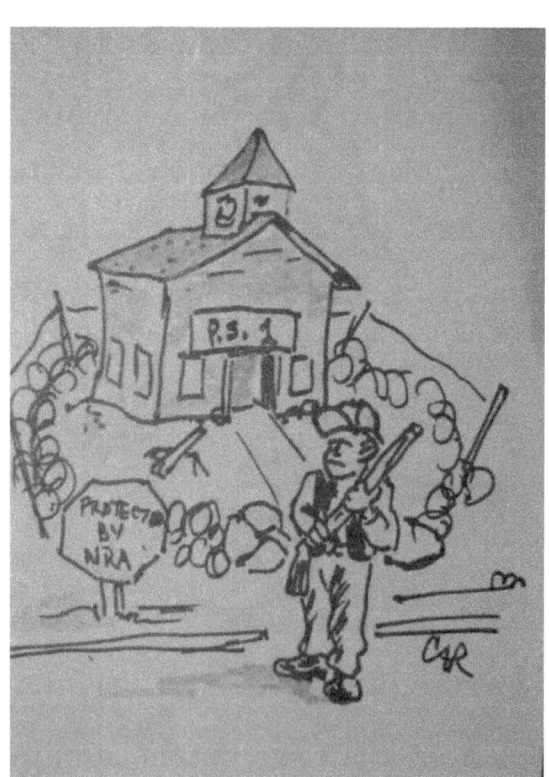

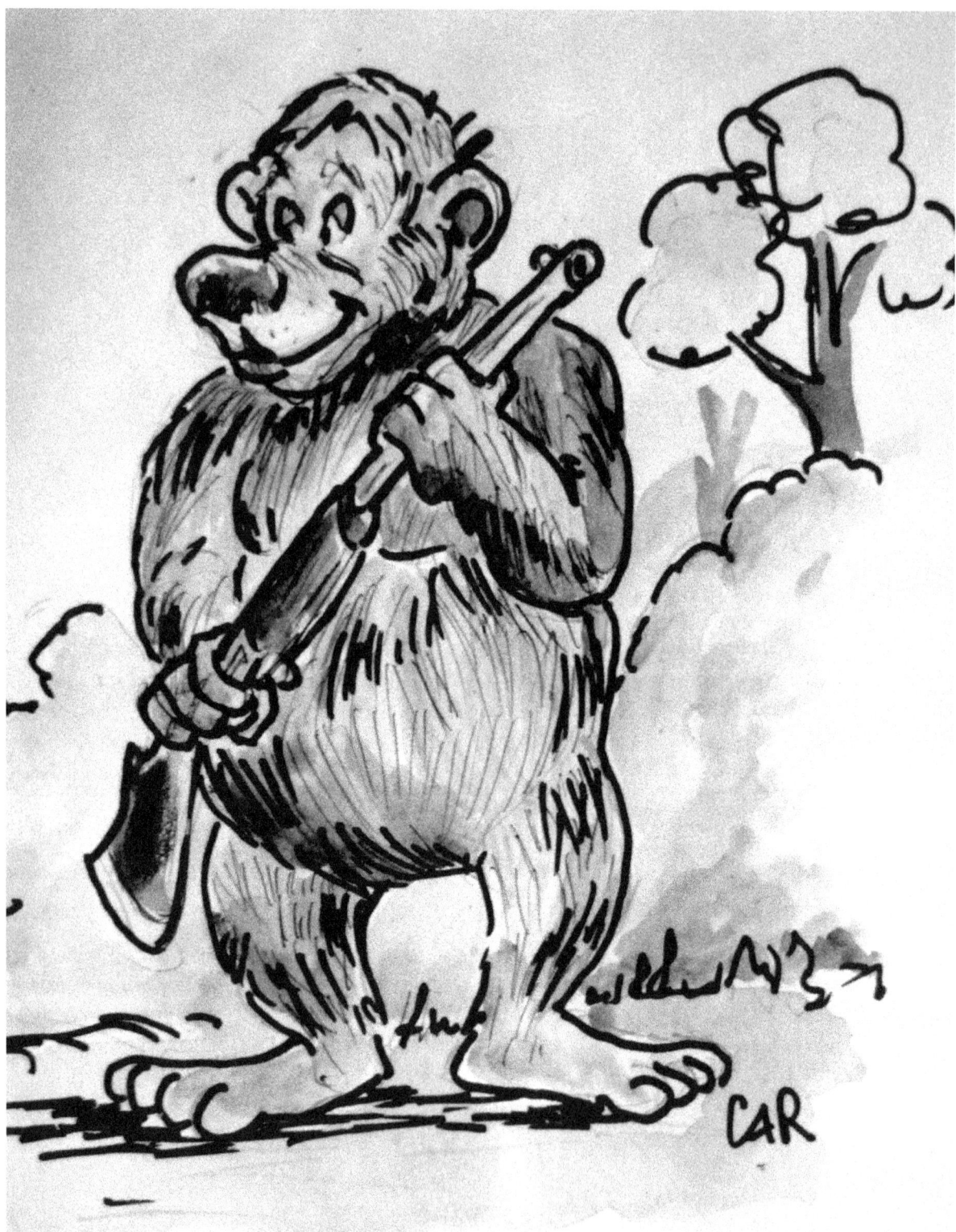

I did this 'I support the right to arm bears' as a play on what I've come to view as the bedtime prayer of Second Amendment devotees.

I grew up in Texas in the 40s and 50s, in a small rural town where everyone hunted, and everyone owned a gun. I was given my first gun, a single-shot .22 rifle, when I was seven. After graduating from high school, I joined the army, and spent the next 20 years around guns, including two tours in Vietnam during the war. I got a chance in the army, both abroad and here in the U.S., to see what guns could do to the human body, especially guns in the wrong hands. As a consequence, I am a strong supporter of sensible gun ownership laws, and things like background checks, eliminating the gun show loopholes, and keeping guns out of the hands of the mentally unstable, or people with a history of abusing others. That sounds a bit draconian, especially to Second Amendment devotees, but that's the way I feel, and the art on the foregoing pages expresses that in no uncertain terms. I'll never be invited to speak at an NRA convention, and because I write a mystery series with a main character who hates guns and, even though he's a PI, refuses to own or carry one, I've had some readers castigate me for it—at least, I hope they're still readers. My response; deal with it.

As the cover suggests, though, it is the Trump phenomenon that this book is about, and how that political revolution has shaped my art. It didn't start with him, per se, but with the three-ring circus that was the early days of the campaign, especially on the GOP side.

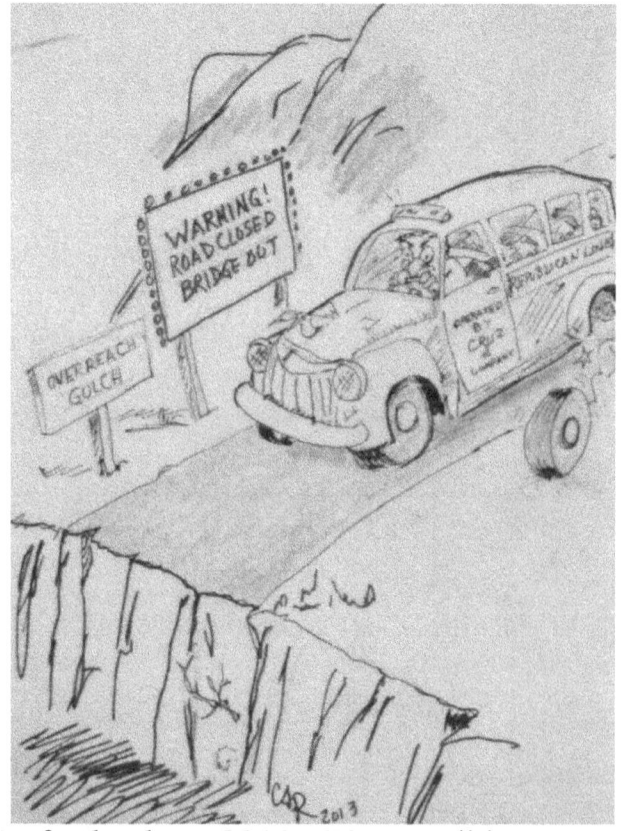

As far back as 2013, GOP candidates were saying things that shocked me to the core.

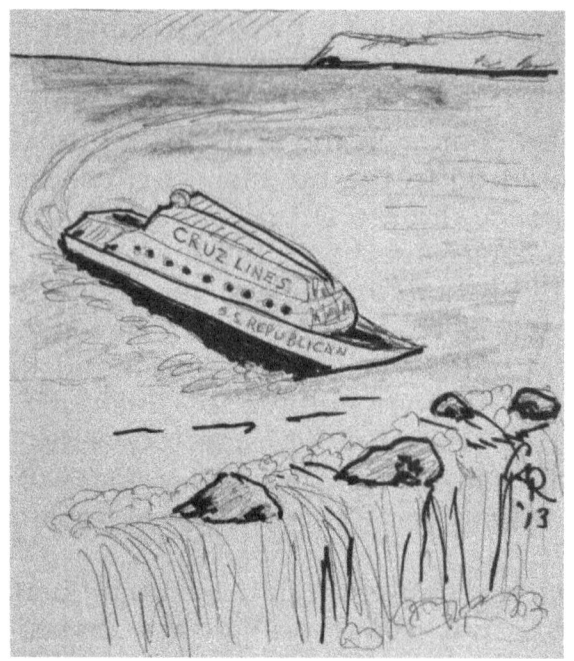

And, I was making what, I suppose, were some dire predictions.

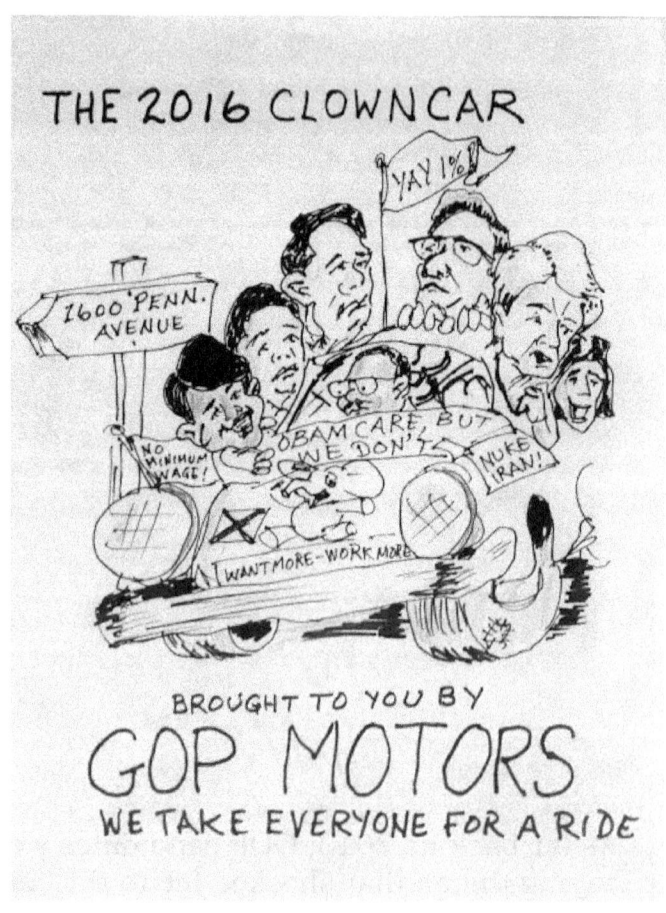

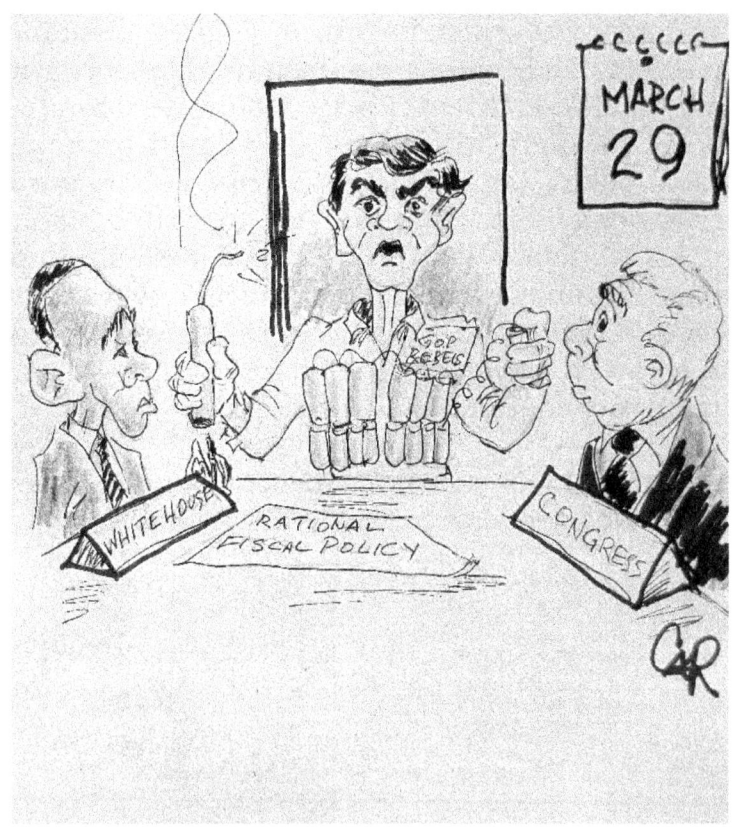

The anti-Obama hysteria was palpable. And then, along came Trump.

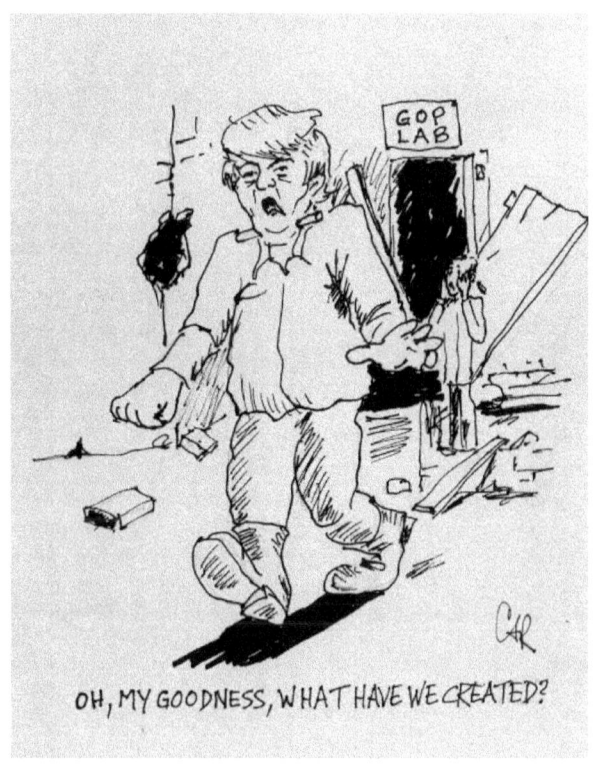

Of course, I'm giving the current crop of GOP politicians too much credit with that last cartoon. They didn't create him. The seeds for this particular weed were sown in 1964, when Barry Goldwater conducted his guerilla campaign to appeal to angry white men who could probably already see the demographic clock ticking against them. This was followed, of course, by Nixon's southern strategy, etc., etc., but the inevitable result, I believe, was a Donald Trump, a candidate who conducted a slash and burn, take-no-prisoners' campaign against even members of his own adopted party (just in case you've forgotten, he once supported Democrats). Recognizing that he wasn't about to go away, I decided to prepare to draw him regularly, which is what I do with recurring characters in my comics.

Below are the steps to creating a cartoon Donald, from the first pencil sketch to a final, shaded rendering of my main character.

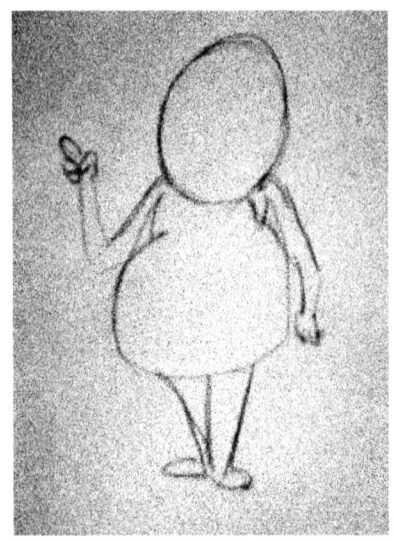
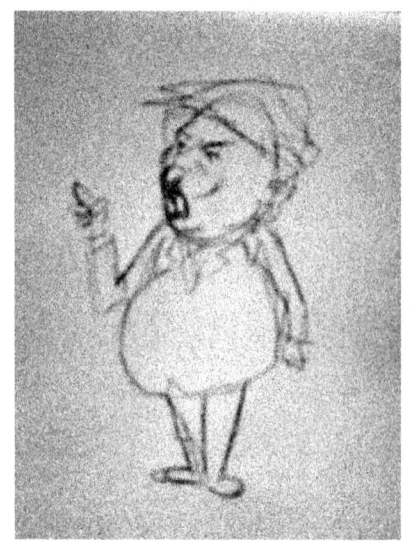
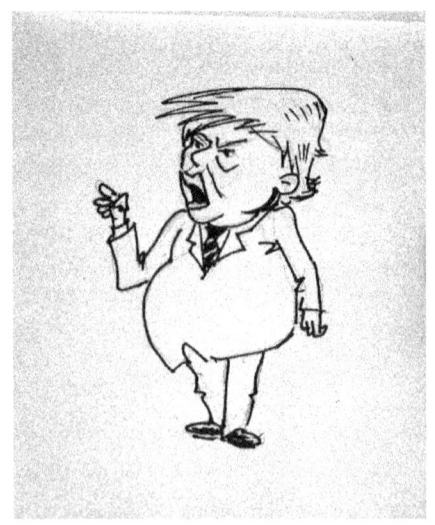
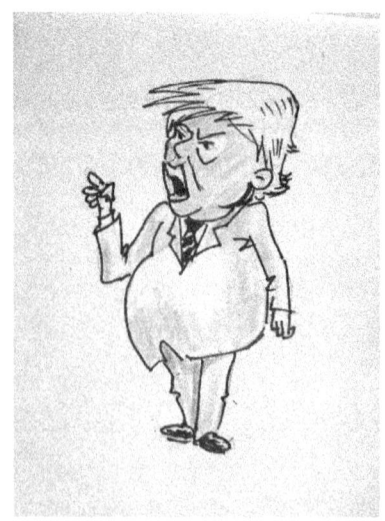

Of course, I couldn't forget his signature logo cap.

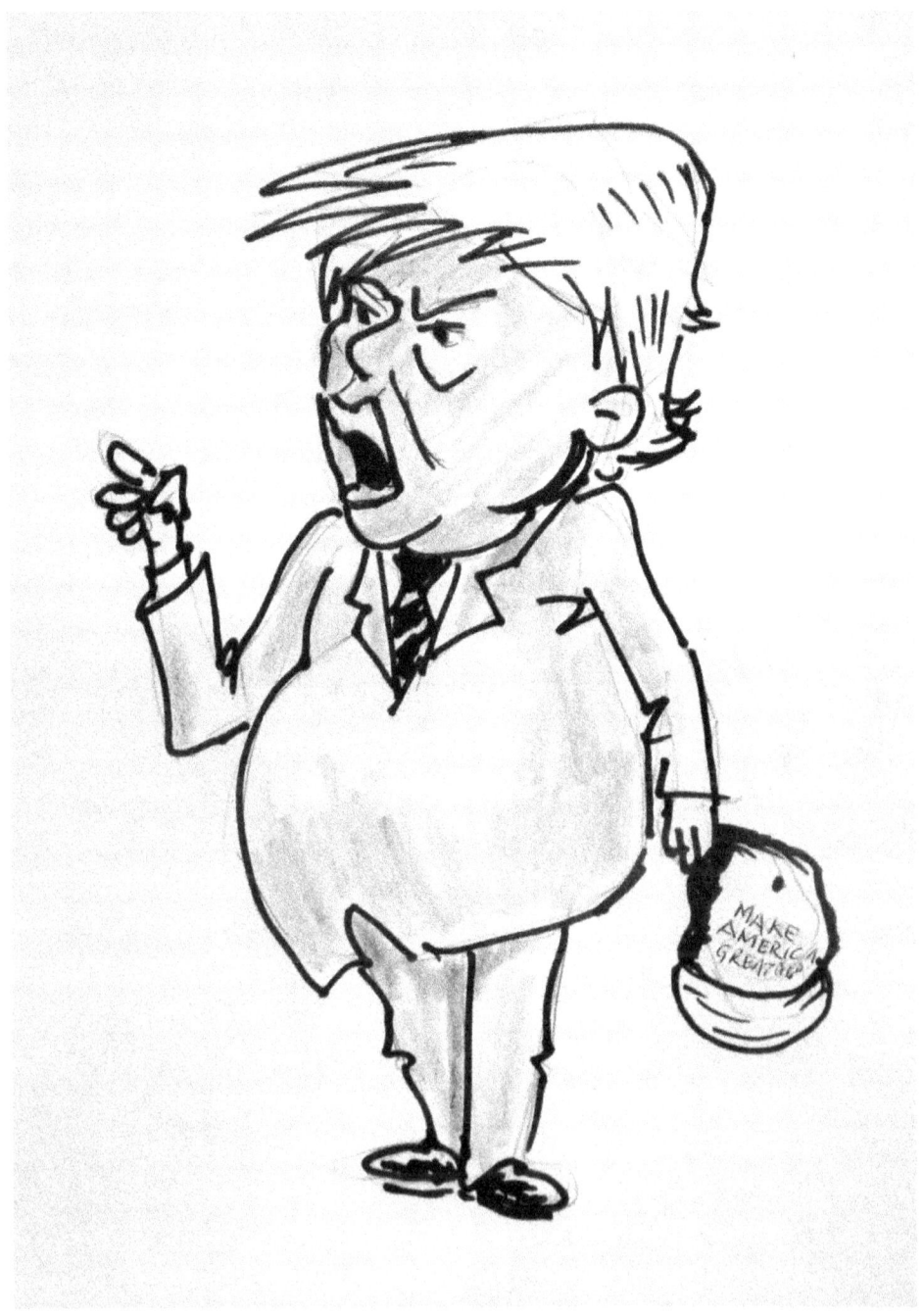

If this looks familiar, that's because a colorized version of it is on the cover of this book.

But, here's the first time I used it in a published cartoon on my blog, 'Free flow of ideas is the cornerstone of democracy http://charlesaray.blogspot.com/, Daily Kos (http://www.dailykos.com/user/Charles%20Ray/) among others.

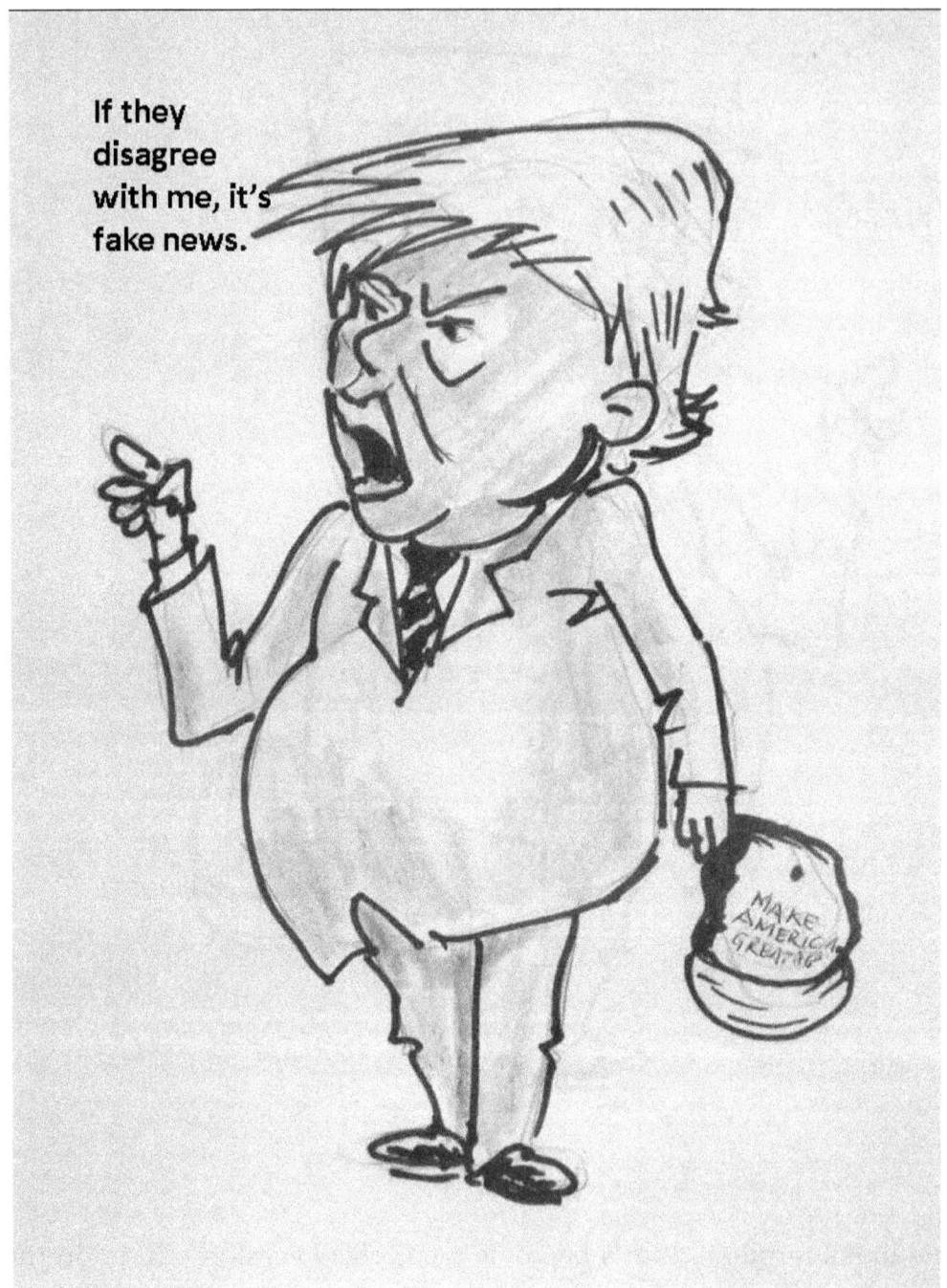

Pay attention to that term, 'fake news;' it'll appear again.

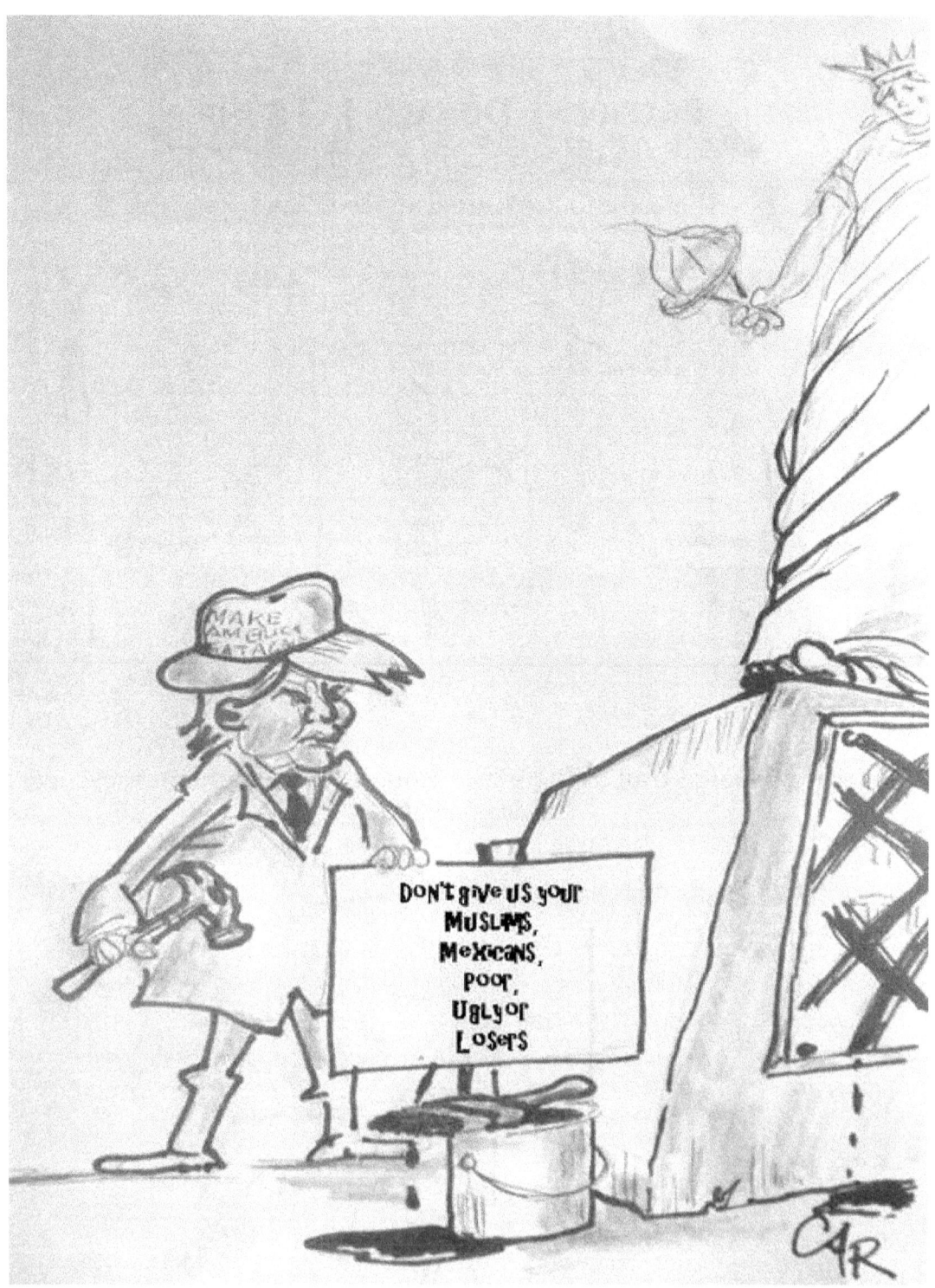

When the candidate started with his anti-immigrant message, this was my reaction.

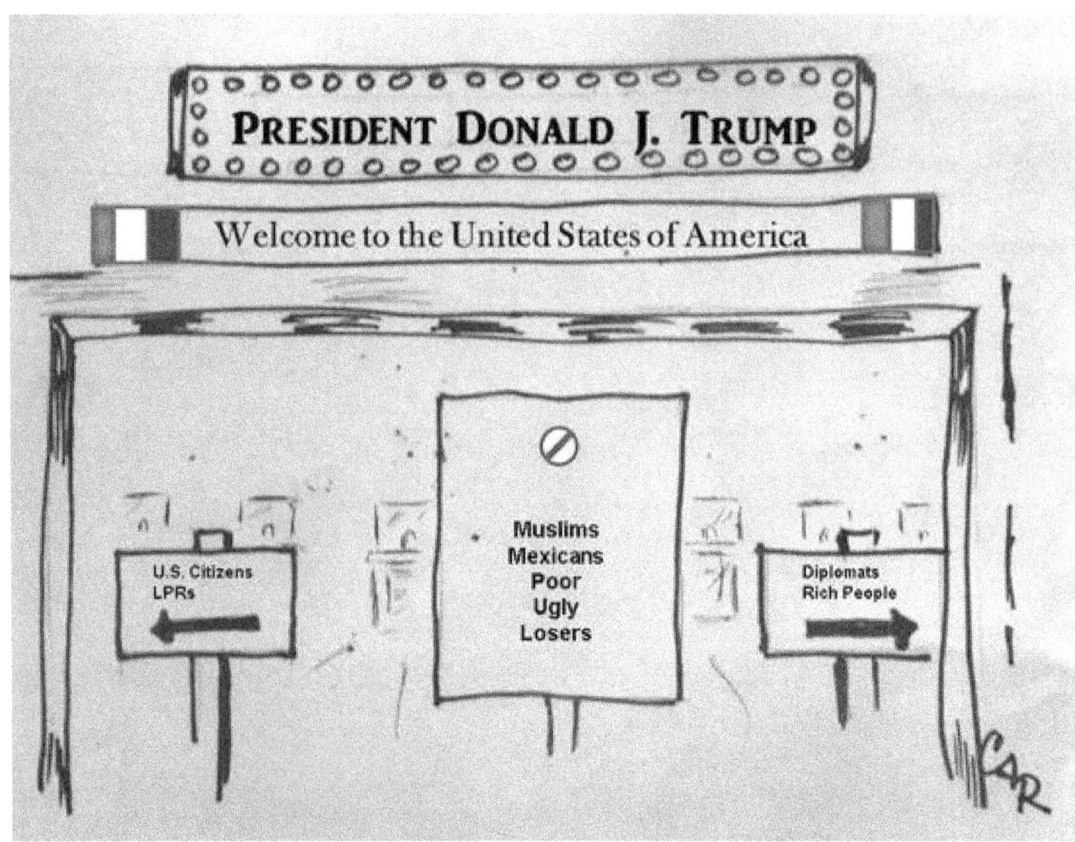

From the campaign trail to the White House, he was still on message, and it was scary.

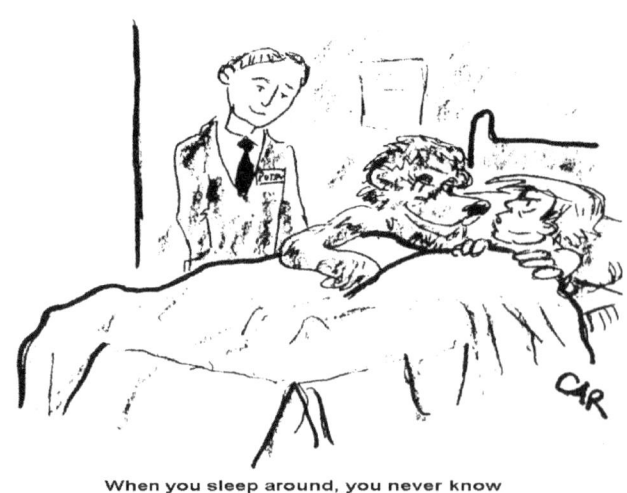

I was concerned about his Russian connection early.

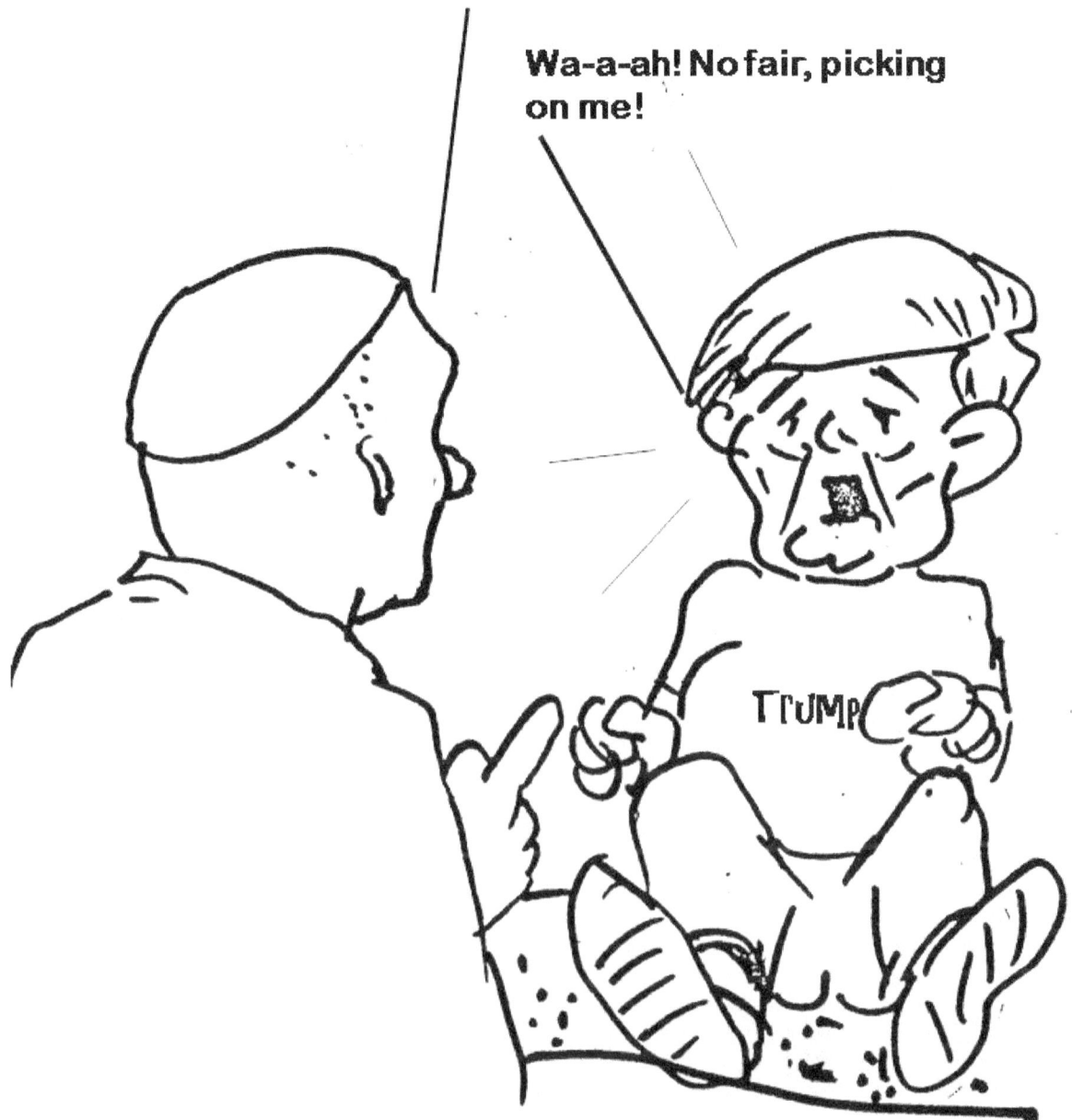

No one was exempt from Trump's ego, not even the Pope.

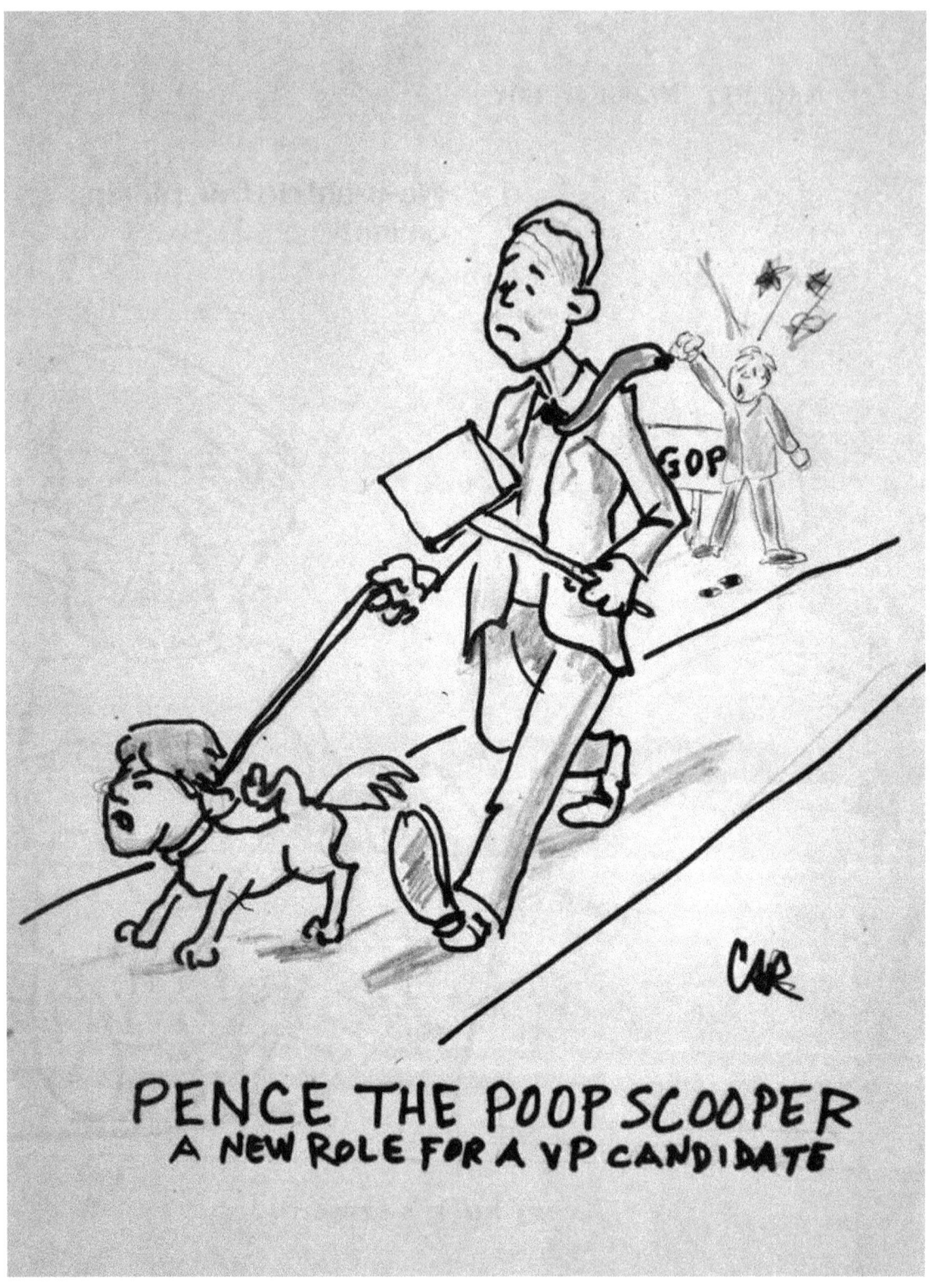

Even during the campaign, VP-candidate Pence had to clean up behind his new boss.

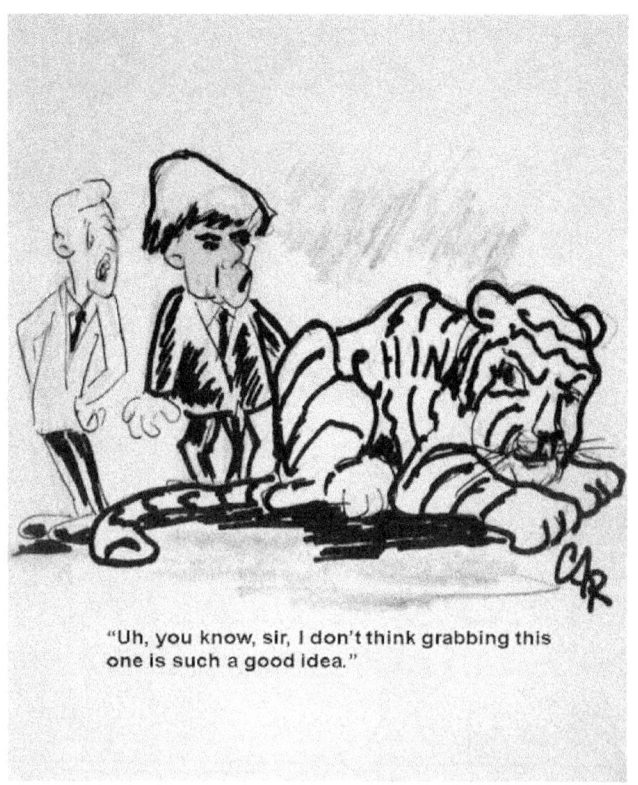

"Uh, you know, sir, I don't think grabbing this one is such a good idea."

And, then there was that 'grabbing them' recording, at around the same time he was poking the Chinese in the eye.

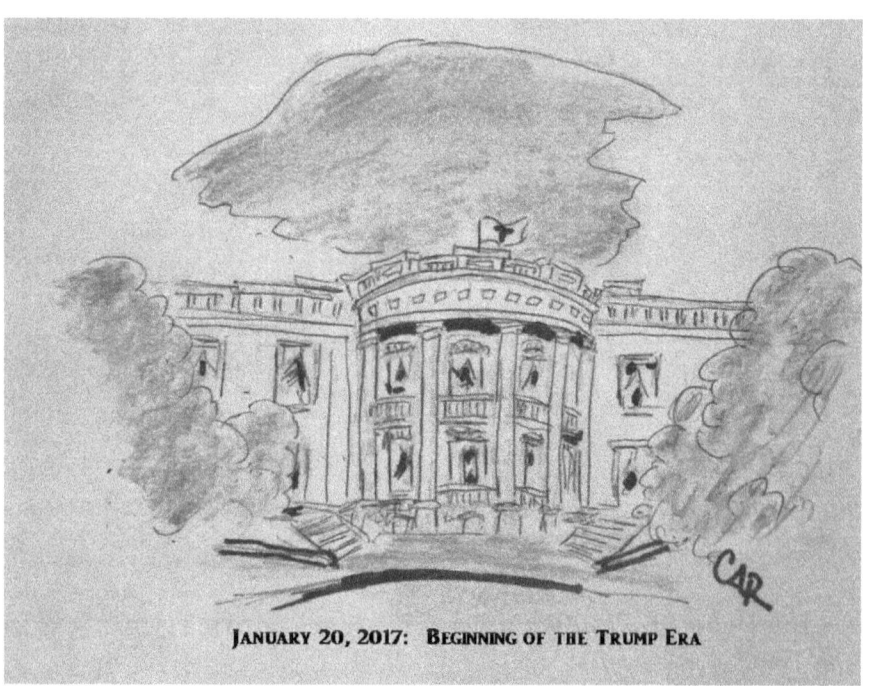

JANUARY 20, 2017: BEGINNING OF THE TRUMP ERA

My Inauguration Day offering.

This was how I saw the GOP and media reaction to Trump's many faults.

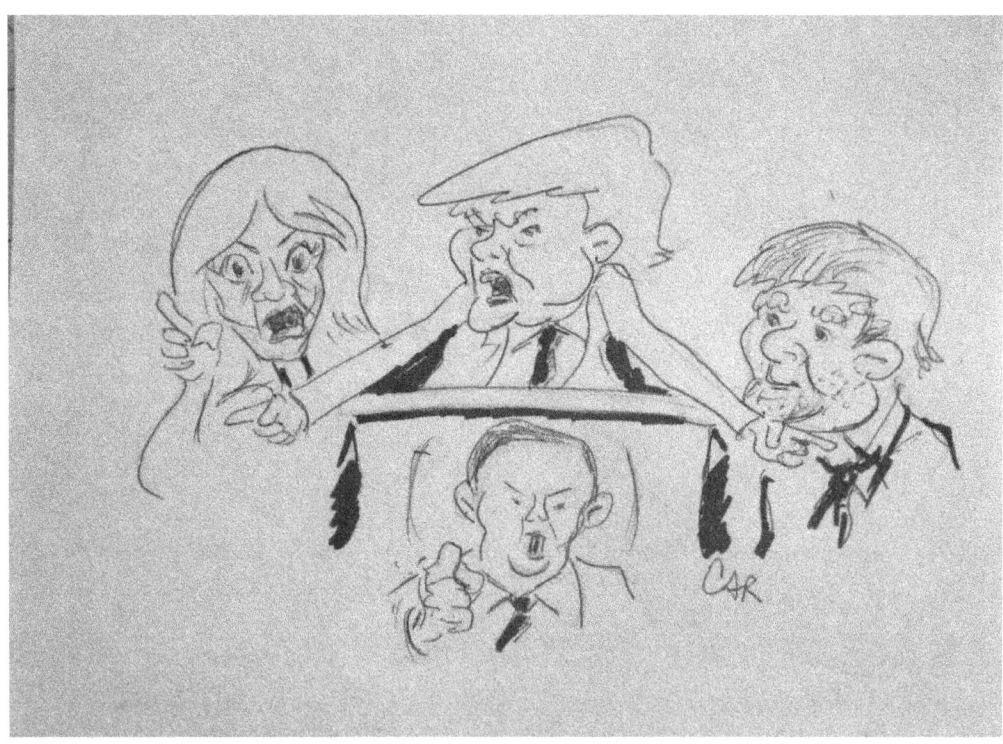

Shortly after he took office, we got a look at some of his close confidantes/advisors – what I called his Rogues Gallery.

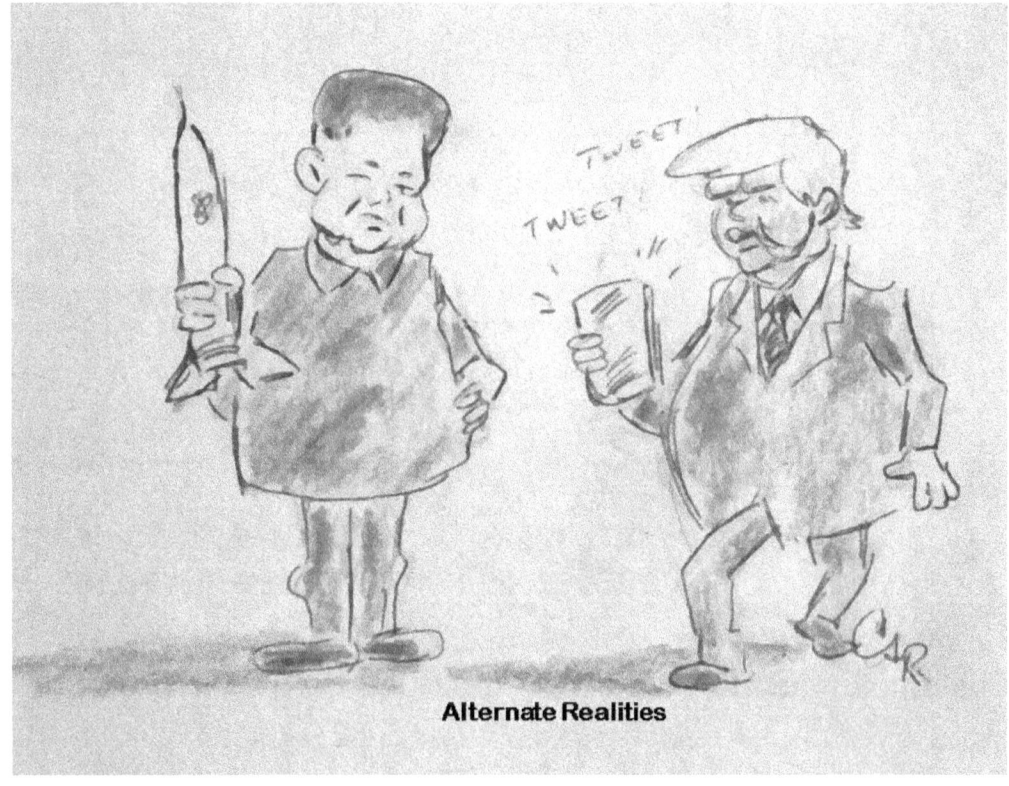

And then, he got into a pissing match with someone who is as impulsive as he is, North Korea's Kim Jong-un.

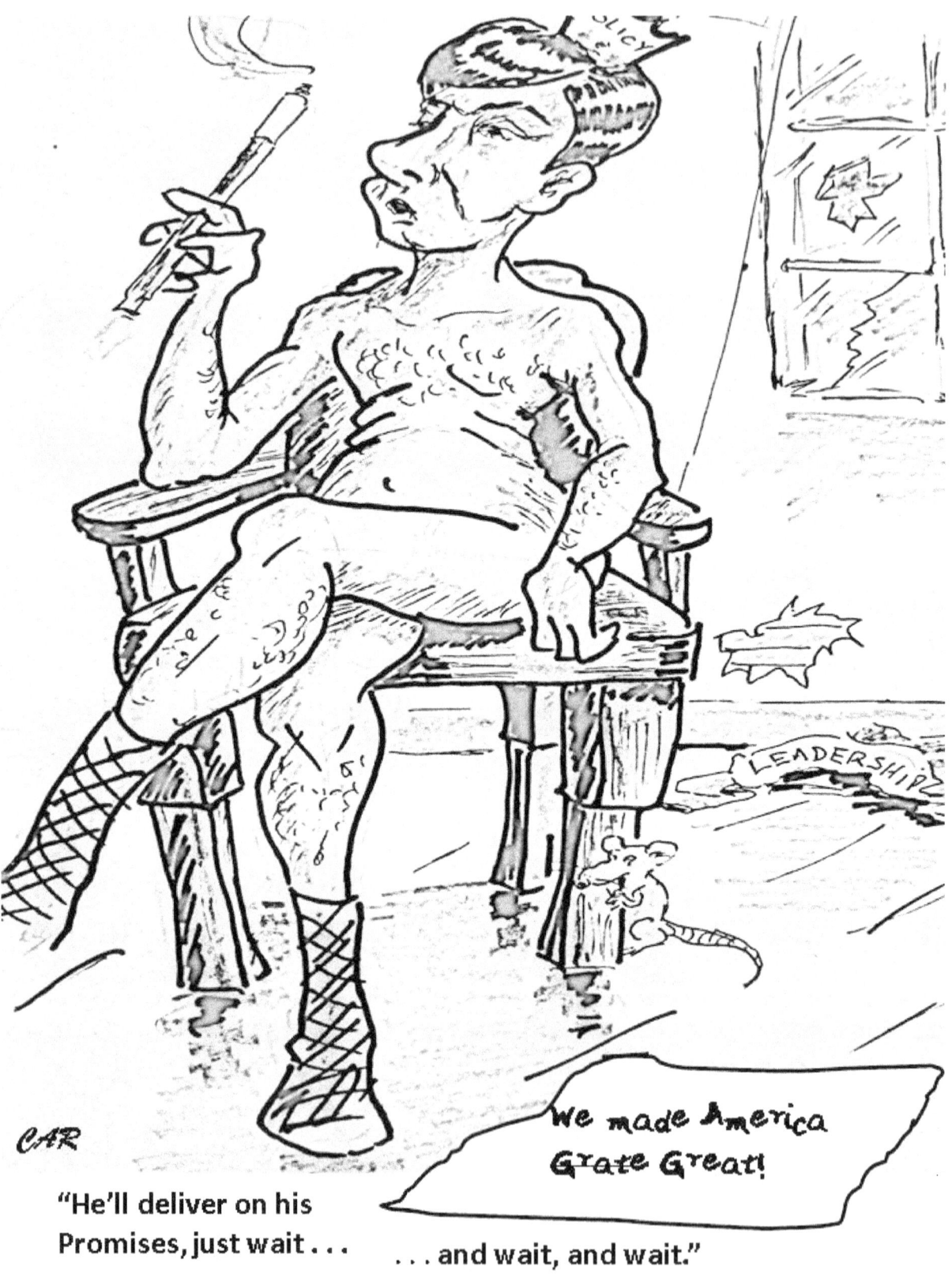

A few weeks after the election, I began to wonder if Trump voters were suffering buyers' remorse yet.

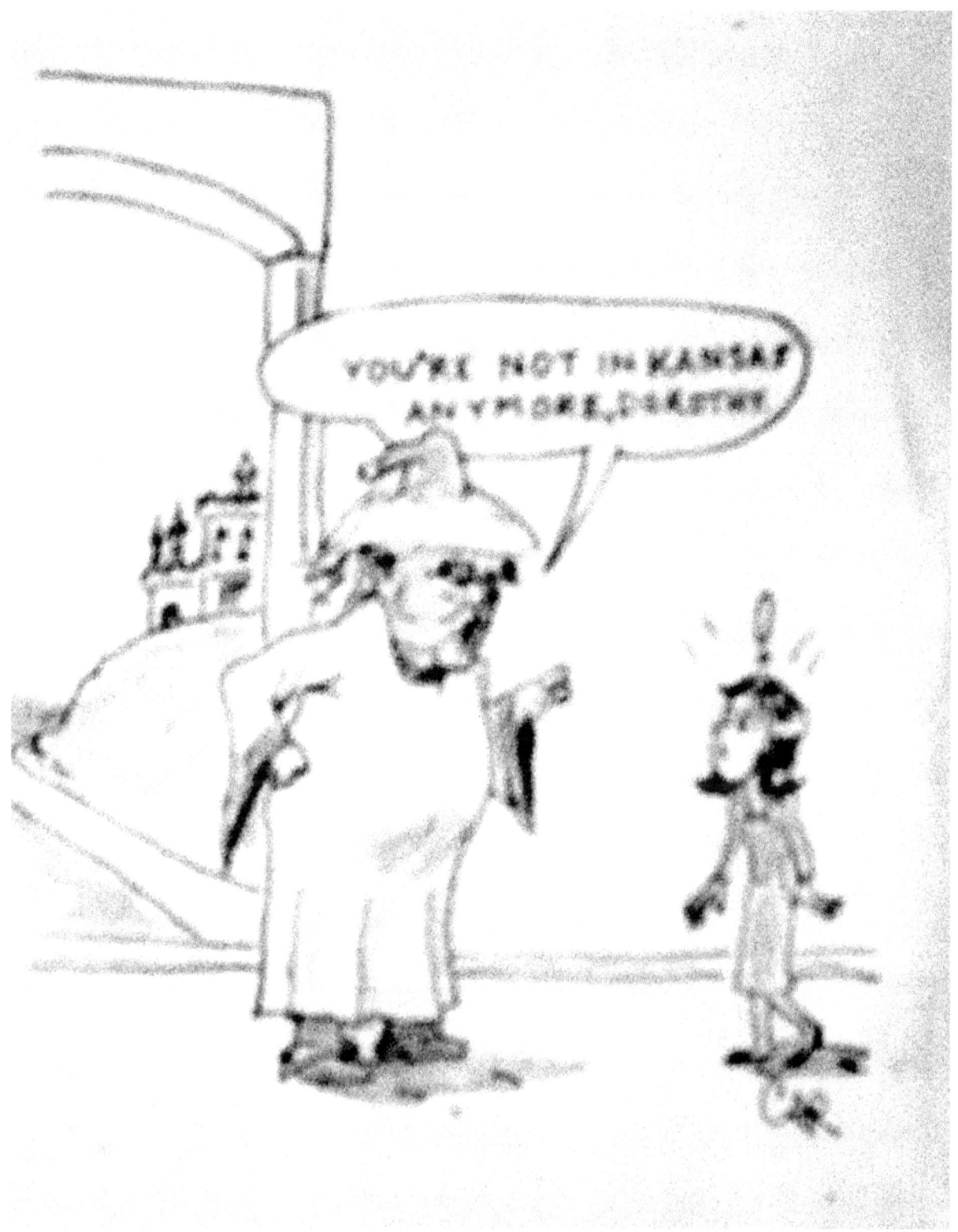

But, he just kept on chugging, his popularity dropping ever lower, and the GOP just kept making excuses for him..

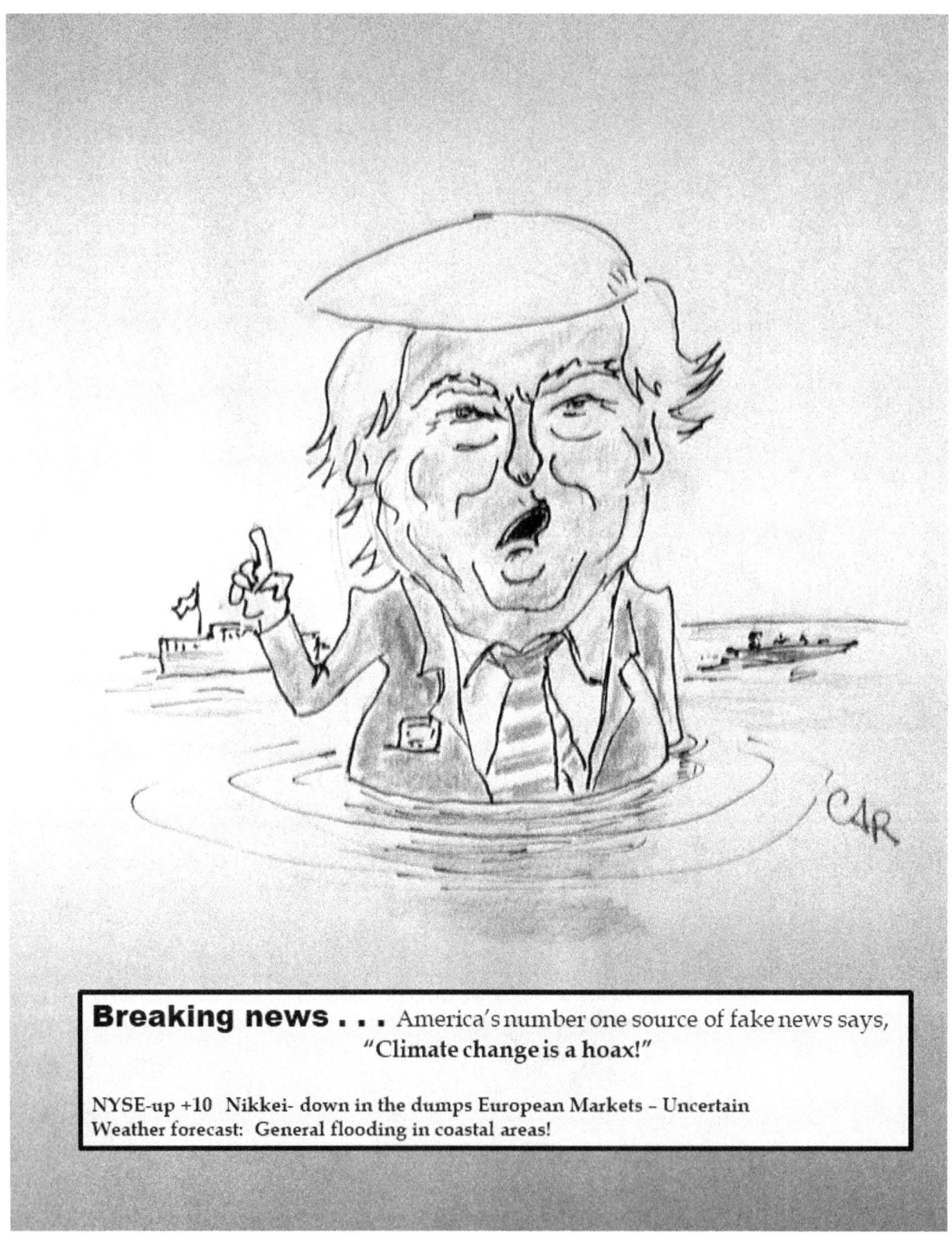

He pulled the US out of the Paris Climate Agreement, to the delight of the climate change deniers and the companies that gloat at the prospect of being able to pollute without restriction.

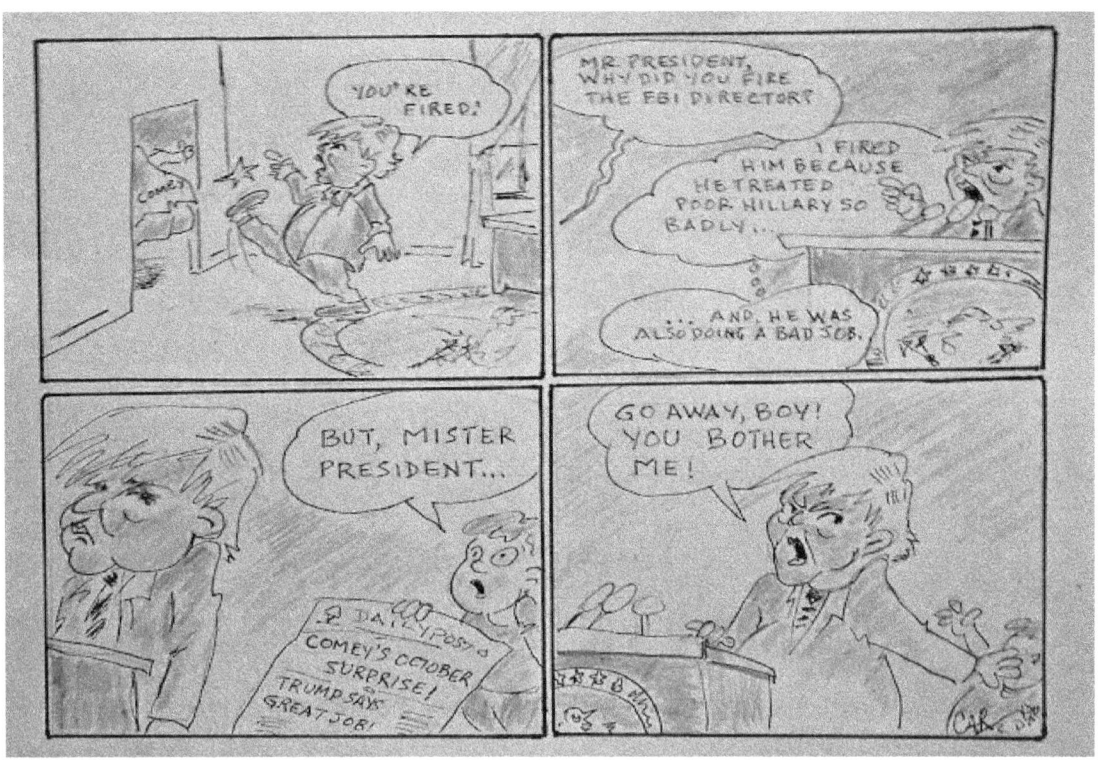

Then, his FBI Director remembered that he had an oath, not to Trump, but to the Constitution, and things started to come apart.

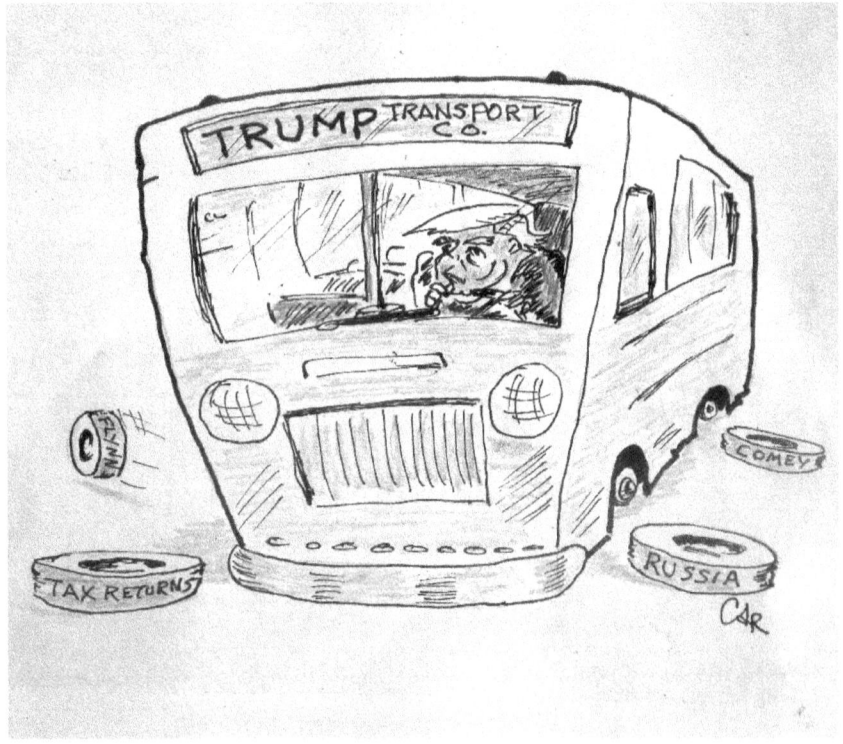

The caption for this was 'The wheels on the bus keep falling off, falling off, . . .'

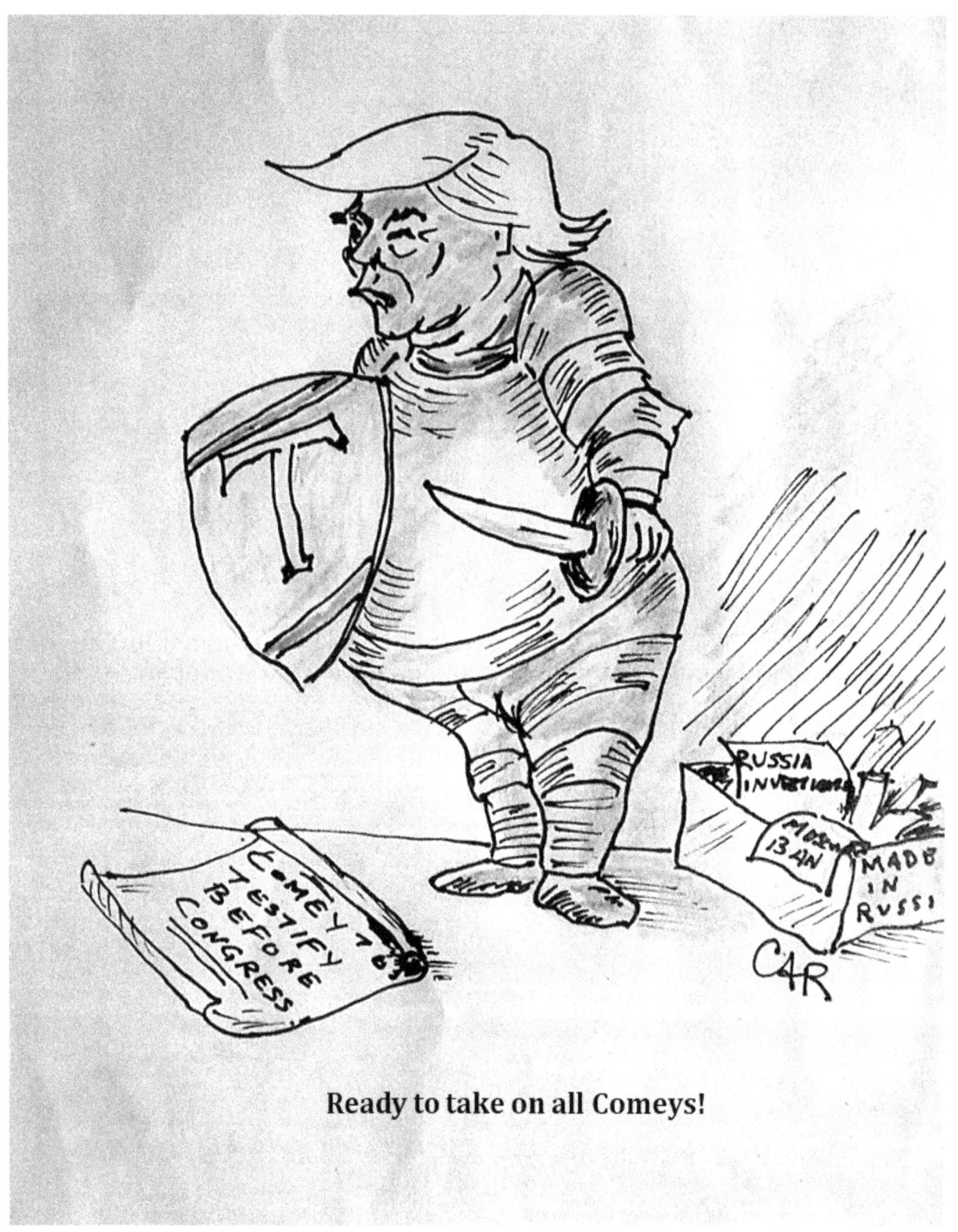

But The Donald doesn't go down without a fight.

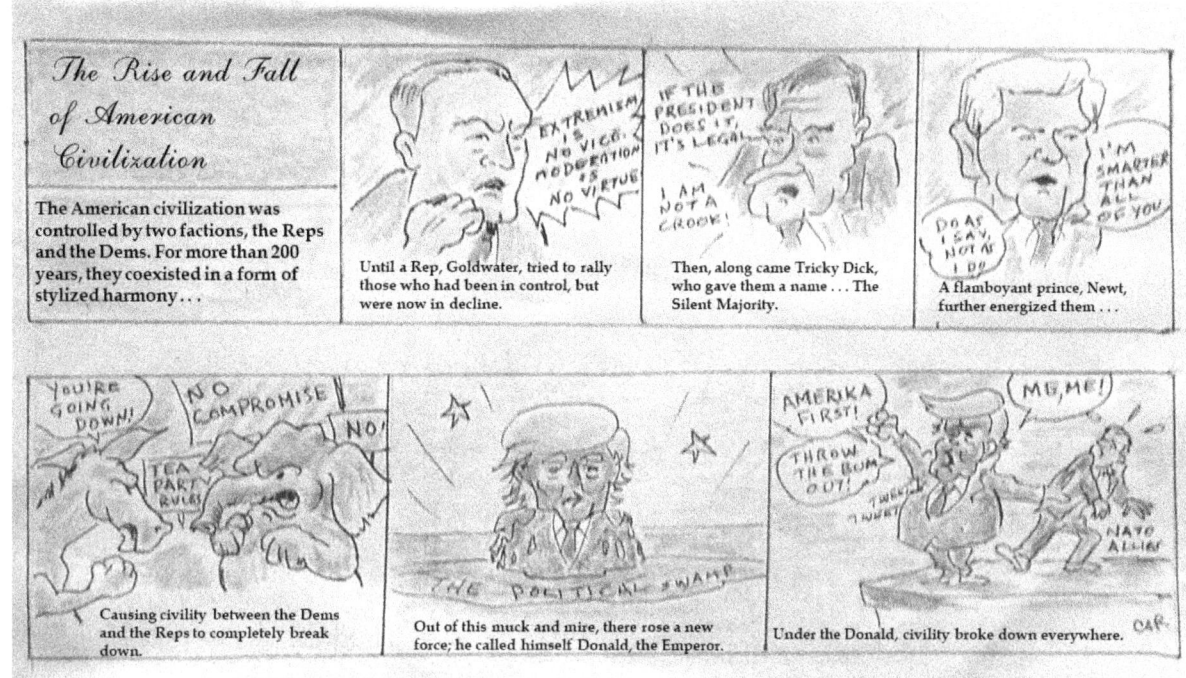

The lack of civility of his campaign moved with him to the White House, but, surprise, he didn't invent it. He was a product of a long-term trend that traces back 1964 and Barry Goldwater.

This probably explains why the GOP finds it so hard to disavow him. While they suffer as much as anyone from his public gaffes, late-night tweets, and his tendency to attack anyone who disagrees with him, is what he deems a 'loser,' or who is getting more media attention than he is. People like Kentucky Senator Mitch McConnell, who is determined to remake the Supreme Court, indeed, the entire federal court system, over in the image envisioned by Goldwater and others many decades ago, a tool to help advance a far, far right agenda, and stem the demographic tide that sees white voters becoming a minority and corporate fat cats restricted in their ability to deep freely into our pockets and the public purse at will.

His unpredictability, which is a long-term political liability, and his disdain for compromise, or admitting to being wrong or responsible for anything, as well as his tendency to strike out in anger when his ego is threatened, seems to be the price they're willing to pay to achieve their unachievable goals.

There you have it folks, my poison pen jottings up to five months into the Trump Administration. I'd like to be able to say that it won't get worse, but I've been around too long to be that naïve. I'll be doing more, probably enough more to do a second edition to coincide with the administration's first anniversary in January 2018. Stay tuned.

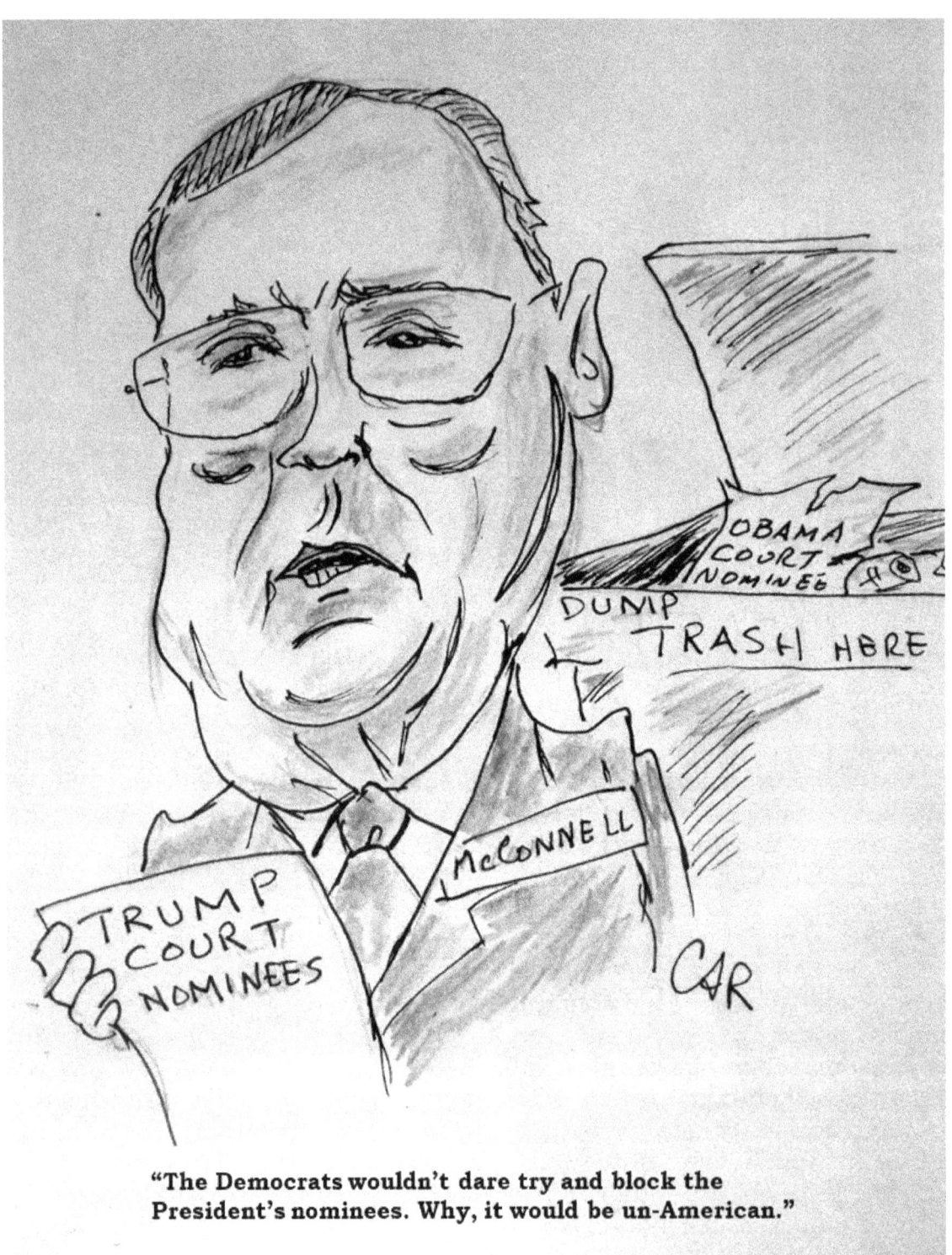

"The Democrats wouldn't dare try and block the President's nominees. Why, it would be un-American."

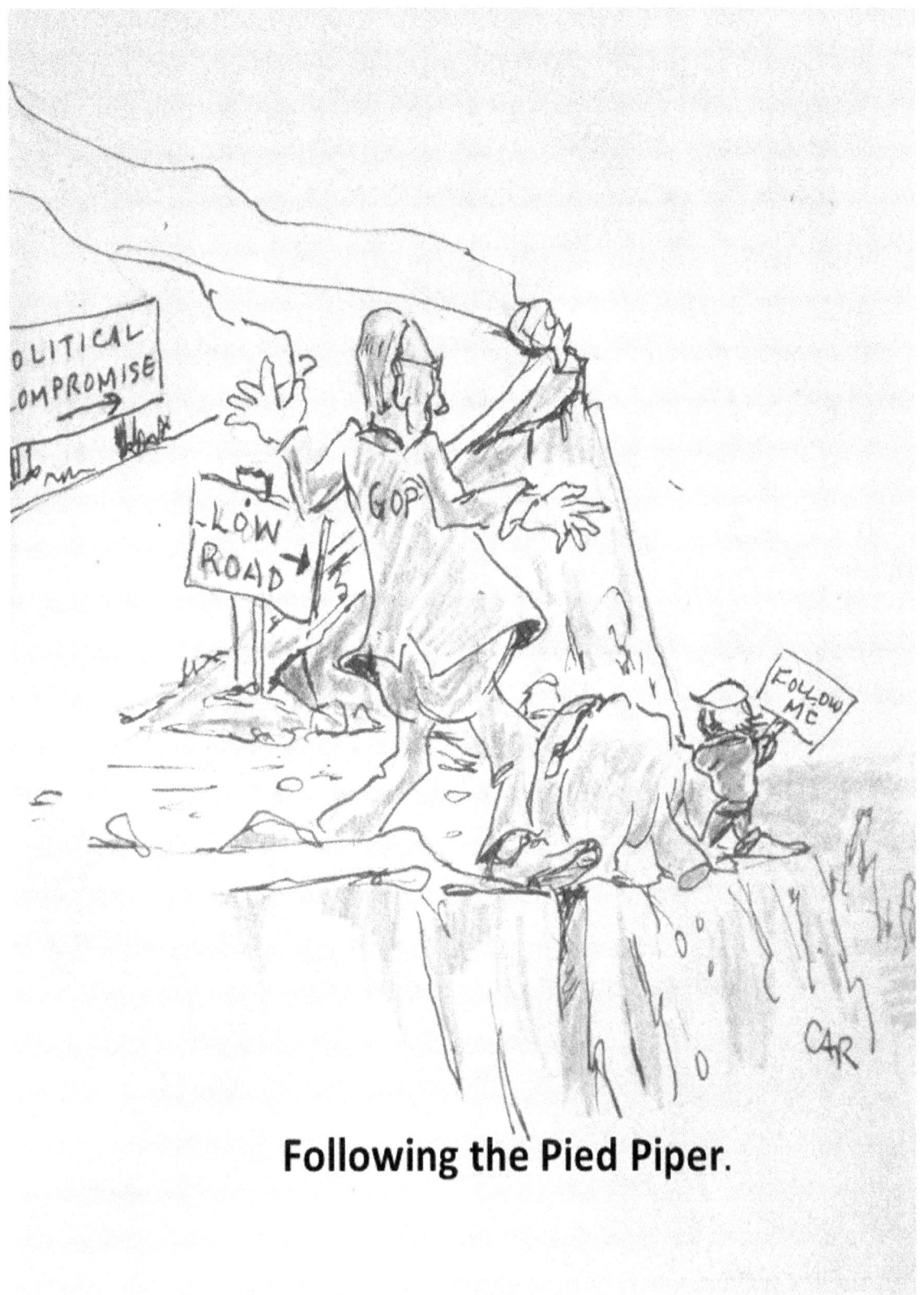

Following the Pied Piper.

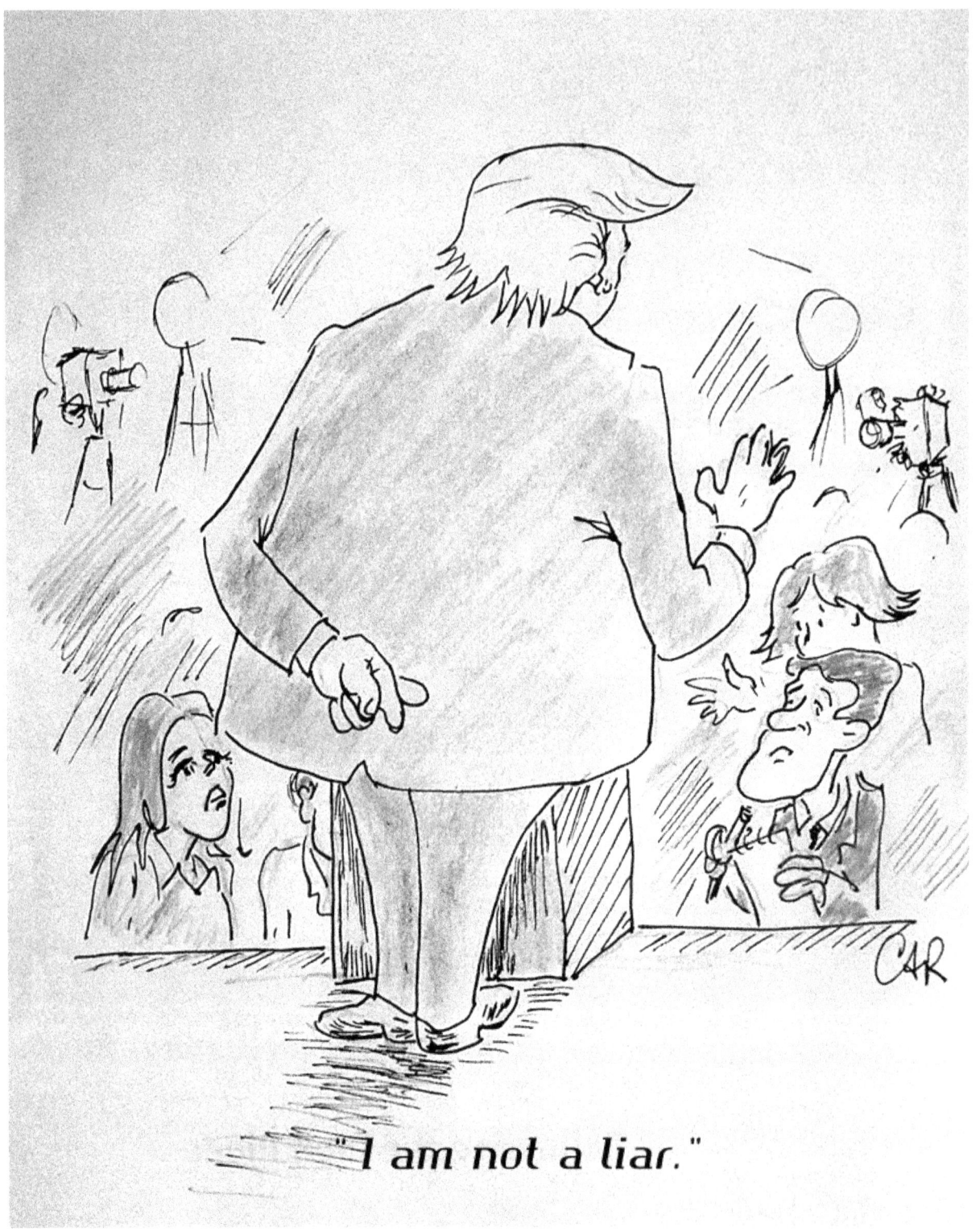

In the meantime, when he's caught in yet another tangle, he continues to do what he's famous for, deny and defame.

Author's Note

If you like what you've just read, please consider leaving a review, even just a few words, on Amazon, Goodreads, or the site from which you purchased the book.

For a look at all of my published books, check out my Amazon author page at: https://www.amazon.com/Charles-ray/e/B006WMLEZK/

CHARLES RAY

ABOUT THE AUTHOR

Charles Ray has been writing, drawing, painting, and taking pictures since his teens. His first professional writing credit was a byline on a short story that won first place in a national Sunday school magazine when he was twelve or thirteen. During high school, he made pocket money by drawing cartoons for his classmates, and taught himself to paint using panels torn off cardboard boxes as canvasses. His first photo was taken when he was about four years old, when his mother left her old Kodak Brownie unguarded on a table (circa 1949) and he did a selfie, which was lost in a fire at his mother's house, so he's unable to claim credit for invention of selfies.

After graduation from high school in 1962, he joined the army, and spent the next twenty years moving about the world, from Germany to Vietnam, writing poems for *Stars and Stripes,* moonlighting as a feature writer and photographer for newspapers and magazines, and while serving at Fort Bragg, NC in the 1970s, serving as the editorial cartoonist for *The Spring Lake News,* a weekly paper in the small community sandwiched between Ft. Bragg and Pope Air Force Base. He's done gag cartoons for a number of publications, many of which are no longer in publication, through no fault of his.

Ray is the author of more than 60 works of fiction and nonfiction, including two mystery series, a western series featuring the famed Buffalo Soldiers of the Ninth Cavalry, and a fictionalized account of the life of Bass Reeves, one of the first African-American deputy U.S. marshals west of the Mississippi, who was hired to track and arrest fugitives in Oklahoma's Indian Territory in the decades after the Civil War.

He grew up in a small town in East Texas (and, by small, the population was 715), which he left before his seventeenth birthday. Since then, he's lived all over the world, and has visited every continent except Antarctica. He now calls Maryland home, living in a Montgomery County suburb just outside Washington, DC.

When he's not writing, drawing, or taking pictures, he plays with his grandchildren, who live nearby, engaged in public speaking or lecturing, and working with a number of non-governmental organizations concerned with history and foreign affairs.

www.ingramcontent.com/pod-product-compliance
Lightning Source LLC
Chambersburg PA
CBHW081102160126
38357CB00033B/423